IMAGES
of Rail

CHATTANOOGA'S
TERMINAL STATION

IMAGES
of Rail

CHATTANOOGA'S
TERMINAL STATION

Justin W. Strickland

ARCADIA
PUBLISHING

Published by Arcadia Publishing
Charleston, South Carolina

Printed in the United States of America

Library of Congress Control Number: 2008940547

For all general information contact Arcadia Publishing at:
Telephone 843-853-2070
Fax 843-853-0044
E-mail sales@arcadiapublishing.com
For customer service and orders:
Toll-Free 1-888-313-2665

Visit us on the Internet at www.arcadiapublishing.com

To my parents, Doug and Vonda, and my sister, Kelsey:
With your love and support, anything and everything is possible for me.

CONTENTS

ACKNOWLEDGMENTS

This book would not have been possible without the full support of the following organizations and individuals. Much gratitude is owed to all the employees of the Chattanooga Choo Choo Hotel and Vacation Complex for their enthusiasm and encouragement throughout this project. Further appreciation goes to Jeff Hight, Debbie Souders, Julie Dodson, and Jim Bambrey Sr. from the Choo Choo's management staff. Also thanks to Mary Helms, Karen Brown, April Mitchell, Suzette Raney, and Jim Reece of the Chattanooga–Hamilton County Bicentennial Library's Local History Department for assistance in scanning and researching photographs and information. Thank you to Steve Cox of the University of Tennessee at Chattanooga Lupton Library for access to historic newspaper articles. Thanks to Bob Clark, fellow railroad enthusiast, for assisting in editing (and keeping me on track). Also much thanks goes to my publisher, Maggie Bullwinkel from Arcadia, for her due diligence and patience with this first-time author. Terminal Station's history would not have been preserved today if it not been for Rabbi David Steinberg. David's previous research, photographs, passion, and first-person knowledge of Terminal Station not only proved useful for this publication but also served as an inspiration for me.

INTRODUCTION

No other city in the Southeast has based its economy and means of transportation so heavily on railroads as Chattanooga, Tennessee. The area's topography encouraged railroads to build along the Tennessee River or through cuts in the ridges to prepare for the climb over the Appalachians or the Cumberland Plateau. The importance of Chattanooga as a railroad center began with the arrival of the Western and Atlantic Railroad on December 1, 1849. The railroad, owned and operated by the State of Georgia, requested permission from the Tennessee state legislature to build the railroad into the state and eventually to a port on the Tennessee River a few miles inland from the state line. Several towns on the Tennessee River were vying for the Western and Atlantic Railway's terminus; however, several influential Chattanoogans assisted in convincing the Georgia state legislature to choose Ross's Landing in Chattanooga. When the first train arrived in the winter of 1849, the railroad was not yet complete. A tunnel still needed to be built in the north Georgia area. Until this tunnel was finished at Tunnel Hill, goods had to be brought over the steep incline of the mountain by wagon and horses to waiting trains on the other side. By May 9, 1850, the tunnel had been finished, and the first train traversed the entire route between Chattanooga and Atlanta. Until 1851, no official passenger station had been built in Chattanooga. The Western and Atlantic built its first "combination depot" (freight and passenger services provided in the same building) on the southwest corner of Market Street and Ninth Street. Today Ninth Street has been renamed Martin Luther King Boulevard and is considered to be in the core of downtown Chattanooga, but in the 1850s, the city limits only went from the Tennessee River to Ninth Street. Thus the first depot for Chattanooga was not located inside the city. For six years, the depot served the 4,000 residents of the city quite well. By 1857, other railroads had built lines into Chattanooga, including the Nashville and Chattanooga Railroad and the Memphis and Charleston Railroad. It soon became obvious that a dedicated passenger station was needed.

The construction of what was to become Union Depot can be traced to two separate building projects. The "Car Shed," as it became known, was completed in 1858. This section was 304 feet long and 100 feet wide. The roof was arched and supported by single spans of bow-string-type iron construction. A ventilator was built extending the entire length of the shed. On each end, two large arched openings allowed two sets of tracks to enter for a total of four tracks through the entire structure. Located at the corner of Broad and Ninth Streets, the Car Shed was set back from Ninth Street some 100 feet. This allowed the tracks to extend that length outside the shed, allowing the steam locomotives heading into the shed itself not to overwhelm the interior with smoke. Through the center length of the shed were ticketing facilities, waiting areas, and railroad offices.

By the 1880s, the passenger facilities within the shed were seriously in need of update or replacement. The decision was made by the Western and Atlantic Railroad to expand Union Depot with the addition of a head house and separate but adjacent freight station. On July 1, 1882, the new passenger head house and freight facilities for Union Depot opened to the public.

Originally the floors were wooden planks over brick foundations, but by 1900, they had been re-laid with Georgia marble. Thanks to a fire in 1911 and then the widening of Broad Street in 1926, the shed was cut back to 124 feet in length, just enough to cover the concourse for the station. Three sets of butterfly sheds were installed some 1,000 feet long to provide cover for passengers.

This arrangement remained in place until Union Depot's demolition in the 1970s. Union Depot began Chattanooga's railroad expansion and station construction. It was only the overcrowding conditions at this depot that led to Central and Terminal Stations' eventual construction.

The opening of Central Passenger Station on the corner of Union (now Thirteenth) and Market Streets provided Chattanooga with needed relief for the overcrowded Union Station. It was originally built in 1871 as a freight depot for the Alabama and Chattanooga Railroad, but the conversion to a passenger station in 1888 added greatly needed capacity to Chattanooga's passenger market. Immediately after Central Station opened, the Cincinnati Southern Railroad and the Alabama Great Southern Railroad (formerly the Alabama and Chattanooga) began full operation of their trains out of the depot. A few years later, the Memphis and Charleston Railroad and the Georgia and Knoxville divisions of the East Tennessee, Virginia, and Georgia Railroad also began scheduling trains into Central. In 1894, the Southern Railway, utilizing Central Station at the time, took over the majority of Chattanooga's railroads, including all but the Chattanooga, Rome, and Columbus Railroad (later the Central of Georgia Railway). By 1900, the six-track shed at Central became overburdened, with 30 scheduled trains per day. An example of how overburdened the station was can be seen by looking at the schedules for January 15, 1908. On that date, 11 trains were scheduled for the six-track station between 10:00 and 11:00 in the morning. Not only were these overcrowded conditions bothersome for the railroad and passengers, but the citizens of Chattanooga were troubled by the fact that Market Street was less than 15 feet away and perpendicular to the shed. Therefore every train that passed through Central blocked Market Street, a major thoroughfare, for a considerable amount of time. Vehicular traffic, pedestrians, and streetcars ceded the right of way to the trains. The area became dangerous—so dangerous, in fact, that the railroad intersection with Market Street was given the nickname "Death Trap," due to the many injuries and fatalities that had occurred there. By 1900, Central Station's constant overuse began to take a toll on the facilities. To prove a point to the railroads, the city building inspector condemned the building due to the filthiness of its toilet facilities.

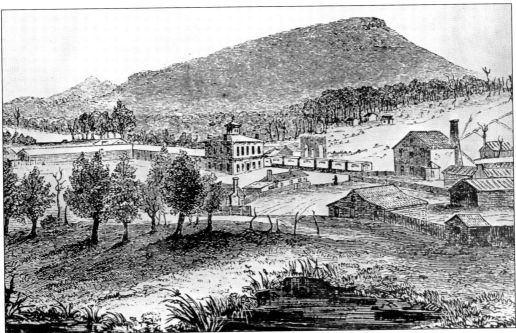

With Lookout Mountain looming in the background, this lithograph shows Chattanooga's first combination depot. This facility was built in 1851 by the Western and Atlantic Railroad for both passenger and freight purposes. The second story housed the offices for the passenger department, while the first floor was for public passenger use and freight operations. (Courtesy of the Chattanooga–Hamilton County Bicentennial Library.)

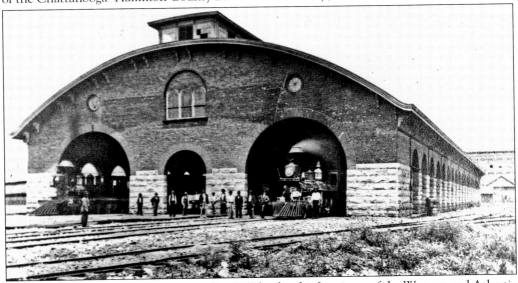

This four-track car shed was constructed in 1858 by the chief engineer of the Western and Atlantic Railroad, Eugene LeHardy. At 304 feet, it became the centerpiece for passenger operations of the three railroads that operated in Chattanooga by that time—the Western and Atlantic, Nashville and Chattanooga, and the Memphis and Charleston. (Courtesy of the Chattanooga–Hamilton County Bicentennial Library.)

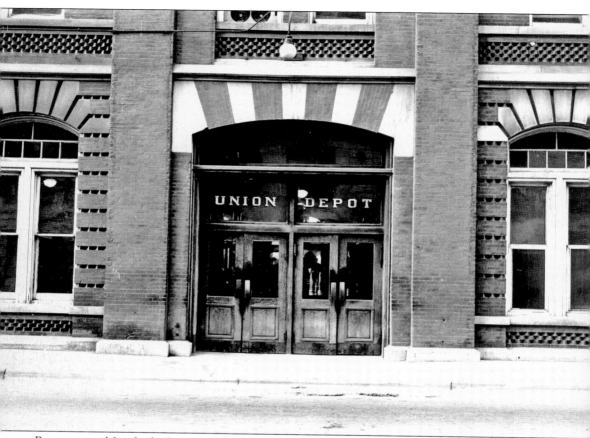

Passenger and freight facilities at the newly re-vamped Union Depot were once again expanded in 1881 with the addition of an antebellum-style passenger head house and adjacent freight building. This antebellum structure was in use until the last passenger train left Chattanooga in 1971. This photograph depicts the double walnut doors to the main entrance of the waiting room. (Courtesy of the Chattanooga–Hamilton County Bicentennial Library.)

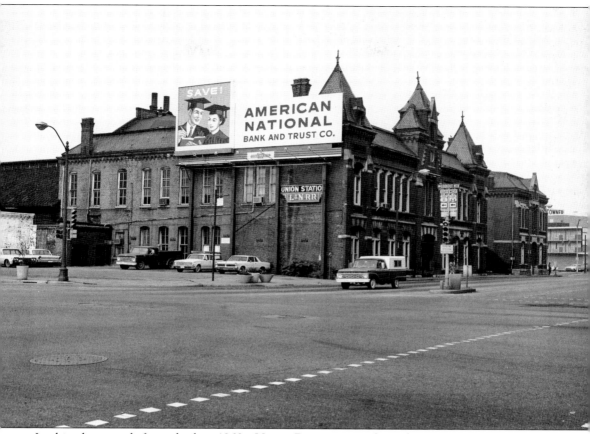

In this photograph from the late 1960s, Union Depot is seen from the corner of Broad Street and Ninth Street. The station has changed little since the 1880s. The freight depot can be seen behind the main passenger structure. The edge of the car shed is on the far left side. (Courtesy of the Chattanooga–Hamilton County Bicentennial Library.)

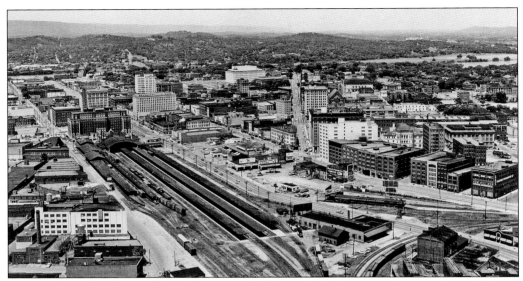

The 1,000-foot-long butterfly-style passenger sheds can clearly be seen in this aerial view. The car shed is much shorter than the original length due to a fire in 1911 that burned down the 285 feet that were farthest from the station head house. The remaining portions of the car shed served as a cover for the concourse area of Union Depot. (Courtesy of the Chattanooga–Hamilton County Bicentennial Library.)

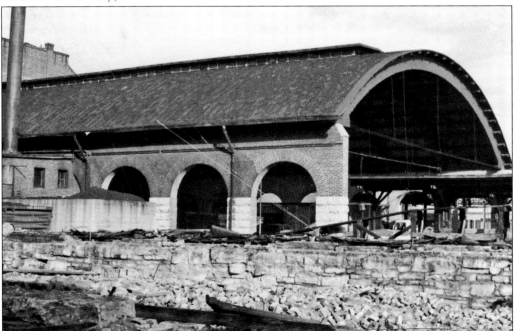

A close-up view of the remaining car shed shows the construction detail. The limestone base supporting the brick arches and roofline came from a local quarry on the original Western and Atlantic Railroad. The ventilator on top of the shed originally was 6 feet high, but a portion was blown off by high winds prior to 1911, and the ventilator was reduced to 3 feet. (Courtesy of David Steinberg.)

One

A New Station is Needed

The opening of Central Passenger Station on the corner of Union (now Thirteenth) and Market Streets provided Chattanooga with the needed relief for the overcrowded Union Station. Originally built in 1871 as a freight depot for the Alabama and Chattanooga Railroad, the conversion to a passenger station in 1888 added greatly needed capacity to Chattanooga's passenger market. Immediately after opening Central Station, the Cincinnati Southern Railroad and the Alabama Great Southern Railroad (formerly the Alabama and Chattanooga) began full operation of their trains out of the depot. A few years later, the Memphis and Charleston Railroad and the Georgia and Knoxville divisions of the East Tennessee, Virginia, and Georgia Railroad also began scheduling trains into Central. In 1894, the Southern Railway took over the majority of Chattanooga's railroads, including all but one of the railroads utilizing Central Station at the time. By 1900, the six-track shed at Central became overburdened, with 30 scheduled trains per day. An example of how overburdened the station was can be seen by looking at the schedules for January 15, 1908. On that date, 11 trains were scheduled for the six-track station between 10:00 and 11:00 in the morning. Not only were these overcrowded conditions bothersome for the railroad and passengers, but the citizens of Chattanooga were troubled by the fact that Market Street was not 15 feet away and perpendicular to the shed. Therefore every train that passed through Central blocked Market Street, a major thoroughfare, for a considerable amount of time. Vehicular traffic, pedestrians, and streetcars ceded the right-of-way to the trains. The area became dangerous—so dangerous, in fact, that the railroad intersection with Market was given the nickname "Death Trap," due to the many injuries and fatalities that had taken place there. By 1900, Central Station's constant overuse began to take a toll on the facilities. To prove a point to the railroads, the city building inspector condemned the building due to the filthiness of its toilet facilities.

In April 1905, the Southern Railway announced its plan to invest more than $4 million in the Chattanooga area, including new and improved trackage to ease congestion within and through the city. One month later, in early May, an additional announcement was made that threw the city into excitement: the railroad planned to build a new passenger facility. This was soon contradicted when, on May 14, the Southern Railway declared that an expansion was to take place at Central Station. This report was purposefully misleading, as the railroad had already begun searching for property in the vicinity. This was intended to thwart any landowners from inflating the price of land knowing the railroad would be purchasing the property. To make certain that the plans would not be uncovered, the railroad hired third parties to make the purchases of land on its behalf. The initial acquisition of land between the current Terminal Station and King Street fell through when the city refused to close little-used streets in the vicinity. The subterfuge of the railroad holding back its intent to build a new depot worked against it, as the city thought the railroad was going to expand the freight yard, only adding to the congestion of downtown. By August 1905, the aforementioned land was abandoned as the potential building site for the station. However, an additional 23 acres were purchased just south of the site, along with the old Stanton House hotel located on the 1400 block of Market Street. The Stanton House hotel, once Chattanooga's most elegant hostelry, had fallen into disrepair and was a shadow of its former self. On August 31, 1905, the Southern Railway made the formal announcement that the site of the Stanton House and surrounding land would become Chattanooga's new railway terminal. By September 8, 1905, all the land needed had been acquired by the railroad, and bidding for the demolition of the surrounding structures had begun.

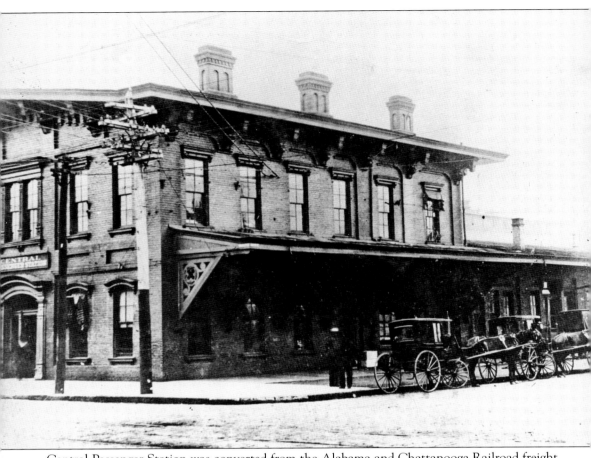

Central Passenger Station was converted from the Alabama and Chattanooga Railroad freight station in 1888. This station relieved the overcrowded conditions at Union Station only to become overwhelmed itself just 20 years later. In this picture from 1900, carriages wait to take arriving passengers to their destinations. (Courtesy of the Chattanooga–Hamilton County Bicentennial Library.)

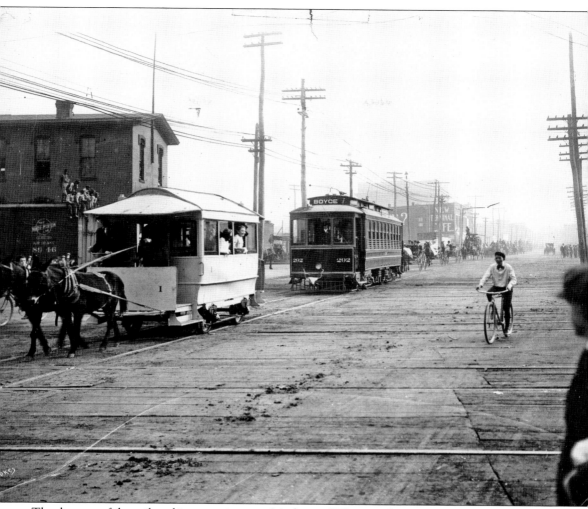

The dangers of the railroad intersection near Market and Thirteenth Streets are apparent during this parade of streetcars and carriages in 1909. The now-closed Central Station is on the far left. With so many tracks crossing this major thoroughfare, it was no wonder it was called a death trap by local Chattanoogans. (Courtesy of the Chattanooga–Hamilton County Bicentennial Library.)

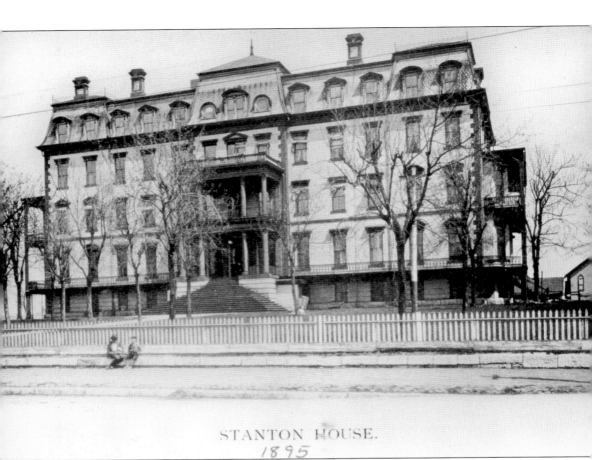

STANTON HOUSE.

1895

Located just a few blocks south on Market Street from Central Station was the Stanton House. This elegant hotel is seen here in 1895, during its heyday. The 100-room, L-shaped hotel lost its importance as the downtown center shifted from nearby Montgomery Avenue (Main Street today) and Market Street to where it is today. (Courtesy of the Chattanooga–Hamilton County Bicentennial Library.)

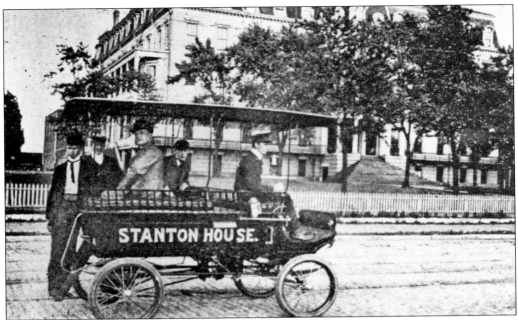

One of the first horseless carriages in Chattanooga was purchased for use at the Stanton House. This vehicle served as a shuttle between the two railroad stations and other Chattanooga attractions and the hotel. The Stanton House also was the first multiple-story hotel with restroom facilities on every floor. One of the first telegraphs for public use in Chattanooga was installed between the hotel and a local horse stable. (Courtesy of the Chattanooga–Hamilton County Bicentennial Library.)

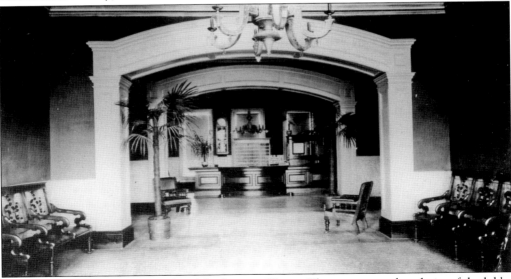

Elegance abounds inside the lobby of the Stanton House. The ornate wooden chairs of the lobby welcome guests to the front desk. J. C. Stanton built the property to host Chattanooga dignitaries and those who could afford such accommodations. Within a few years of this photograph, the hotel would become property of the Southern Railway. (Courtesy of the Chattanooga–Hamilton County Bicentennial Library.)

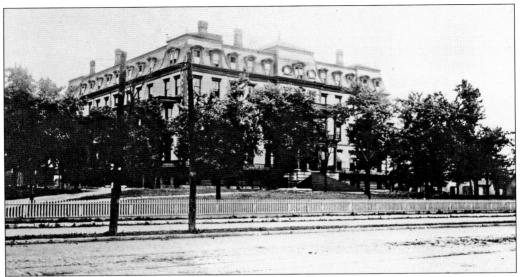

Ownership of the Stanton House had changed hands several times before the beginning of the 20th century, until it was eventually purchased by Z. C. Patten, a local Chattanooga businessman. By 1905, it was falling into disuse. Soon rumors spread about its purchase and use by the Southern Railway as office space. This was soon dispelled, as the railroad made its announcement that the site would be a new station. (Courtesy of David Steinberg.)

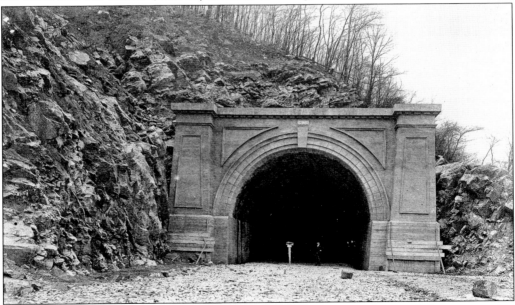

The Southern Railway invested millions of dollars on capital projects along with the construction of Terminal Station. This photograph depicts the northernmost entrance of the tunnel underneath Lookout Mountain before tracks have been laid. The new main line through the area was to be a part of the "Stevenson Extension," the plan to eliminate the Southern Railway's use of trackage rights—an arrangement whereby one railroad pays another for the use of its tracks—over a rival railroad. The railroad ran out of money, and only a few miles were ever completed. (Courtesy of the Chattanooga–Hamilton County Bicentennial Library.)

Two

PLANNING AND
CONSTRUCTION OF
TERMINAL STATION

On May 10, 1906, the Southern Railway chose the final plans for the station in Chattanooga, Tennessee. A prominent New York City architect, Donn Barber, won the bid.

The design that was eventually used for the Chattanooga terminal could be traced back to Barber's college years. Barber, an American by birth, attended one of the most famous art schools in the world, L'Ecole des Beaux Arts in Paris, France. As a student between 1895 and 1898, he studied architecture in the Beaux Arts style. One of the favorite institutional events that occurred annually at the school was a student-led competition in each department. Each year, the architecture department offered a prize to the student with the best design for a specified theme. One year while Barber was in attendance, the theme was to design a railroad terminal suitable to the needs of a large city. The students' options were completely open; there were no limitations as to size, cost, or materials. The first-prize winner was the work produced by Donn Barber. When Southern Railway's president, Samuel Spencer, asked the railroad's chief engineer to search for station designs, Donn Barber's design was submitted. By this time, Barber was an established architect in New York. President Spencer was in awe of the young architect's design and overall look of the station, save one aspect. He asked Barber if he could alter the interior of the station to resemble the then-fashionable National Park Bank (now Chase Manhattan Bank) in New York City, also a Barber design. Barber agreed to Spencer's request, and the last modifications of the blueprints incorporated not only Barber's award-winning design but also the interior of a building that had earned much admiration.

With demolition work of the Stanton House and construction soon to begin, the Southern Railway, then operating several divisions in the Chattanooga area, brought the divisions together to form the Chattanooga Station Company. The charter members of this organization convened immediately and Maj. Henry Fonde was named president of the new company. Work began on January 2, 1906, when local contractor R. L. Wescott and Company was awarded the demolition contract for the Stanton House and surrounding properties that were acquired by the Southern Railway. In less than two months, the buildings were razed and grading began to level the 23-acre station complex. Terminal Station, one of the largest construction projects ever undertaken in Chattanooga, employed approximately 100 men at the height of construction. Over 11 contractors were needed to design, fabricate, and install everything from the lighting and electrical work to hardware and the steam lines feeding the trains from the in-house boiler room. The contract to build the main edifice itself was awarded to a New York firm, Wells Brothers Construction Company. This contractor was supervised by Maj. W. Dunbar Jenkins, Southern Railway's chief engineer of construction. Wells Brothers had the primary responsibility for completion of the main terminal, baggage and express building, telegraph office, stationmaster's office, signal tower, and steam plant.

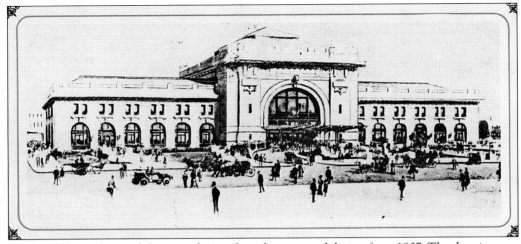

Terminal Station's initial design is depicted on this postcard dating from 1907. The drawing was featured in many newspaper and magazine articles after the announcement of the new station. Several changes were made after the initial drawing. The additional floor on the north and south wings and covered overhang at the entrance were never implemented. (Courtesy of the Chattanooga–Hamilton County Bicentennial Library.)

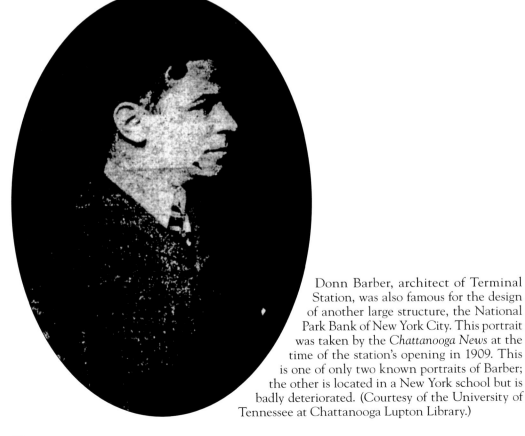

Donn Barber, architect of Terminal Station, was also famous for the design of another large structure, the National Park Bank of New York City. This portrait was taken by the *Chattanooga News* at the time of the station's opening in 1909. This is one of only two known portraits of Barber; the other is located in a New York school but is badly deteriorated. (Courtesy of the University of Tennessee at Chattanooga Lupton Library.)

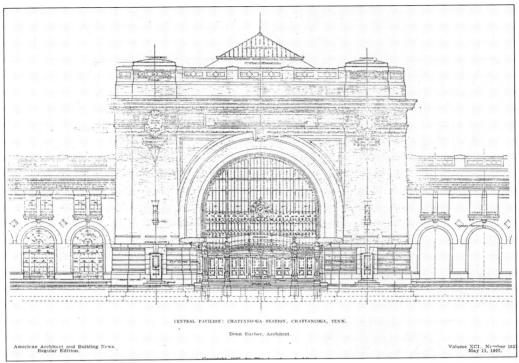

CENTRAL PAVILION: CHATTANOOGA STATION, CHATTANOOGA, TENN.

Donn Barber, Architect.

American Architect and Building News.
Regular Edition.

Volume XCI., Number 1637
May 11, 1907.

The massiveness of the brick arch can be seen in this architectural drawing of Terminal Station. When constructed, this was the largest self-supporting brick arch in the world. The additional floor of the station that was never built can also be seen above the smaller arches on the north and south wings. The Beaux Arts style of architecture that influenced Donn Barber can easily be seen. (Courtesy of the Chattanooga–Hamilton County Bicentennial Library.)

Terminal Station was built as two different structures combined. One was the outside brick edifice; the other is the steel superstructure to support the domed ceiling and concourse roof. Only the steel arches inside the waiting room support the weight of the ceiling. Terminal Station is one of the few buildings in which the primary supports can clearly be seen in all areas. (Courtesy of the Chattanooga–Hamilton County Bicentennial Library.)

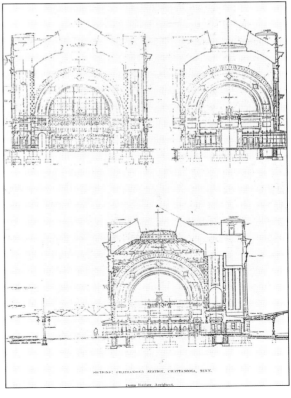

SECTIONS: CHATTANOOGA STATION, CHATTANOOGA, TENN.

Donn Barber, Architect.

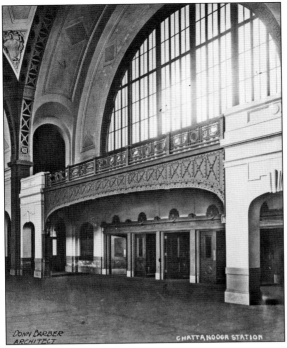

Photographs taken inside Terminal Station prior to World War II are rare. This photograph shows the entrance of the station just prior to opening in 1909. The overhead walkway supported by the steel truss was going to be a crossover between the upper floors of the wings. When the additional floors were eliminated from the building plans, the walkway had to be kept, as the steel was already in place. This created a "walkway to nowhere" that can be accessed by a stairwell on each side. (Courtesy of the Tennessee State Archives and Library.)

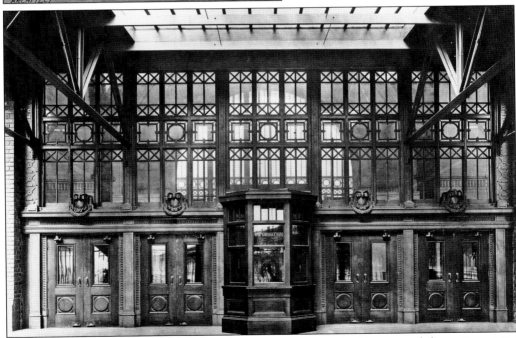

This photograph was taken from within the station concourse looking toward the main waiting room. The information booth in the middle of the doorways was initially used for schedule inquiries but later served the Pullman Company as a passenger check-in for sleeping car service. Notice the ample lighting provided by the skylights—even the glass on the opposite side of the waiting room can be seen. (Courtesy of the Tennessee State Archives and Library.)

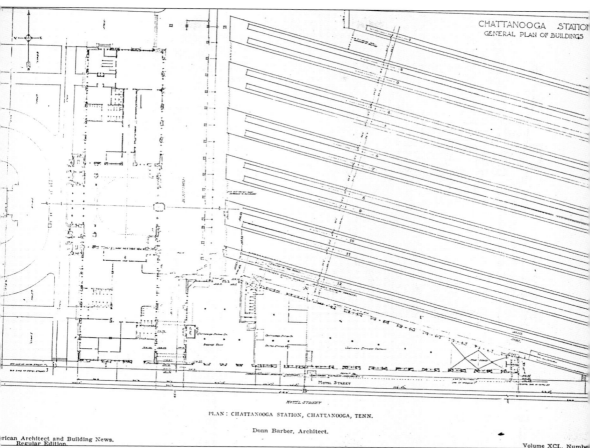

PLAN : CHATTANOOGA STATION, CHATTANOOGA, TENN.

Donn Barber, Architect.

rican Architect and Building News.
Regular Edition.

Volume XCI. Numbe

This overhead view from the master plan of the station is an excellent way to see how space was utilized. A close look reveals the separate facilities for white and black passengers during the Jim Crow era. The baggage and express building is separated from the terminal by a portion of the concourse. All but one of the 14 tracks entering the station can also be seen. (Courtesy of the Chattanooga–Hamilton County Bicentennial Library.)

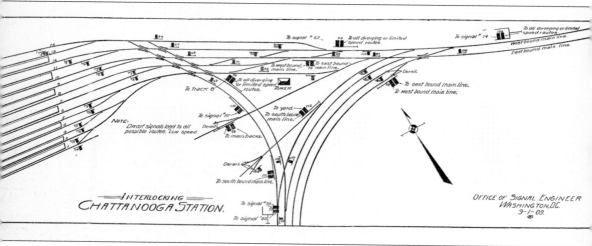

A considerable amount of design and planning had to go into the tracks accessing the station. This drawing depicts all switch and signal locations controlled by Terminal Tower, seen in the middle of the drawing. This layout created a three-point turnaround for trains so that they could back into the loading platforms. Two trains could be turned safely at one time. (Courtesy Chattanooga–Hamilton County Bicentennial Library.)

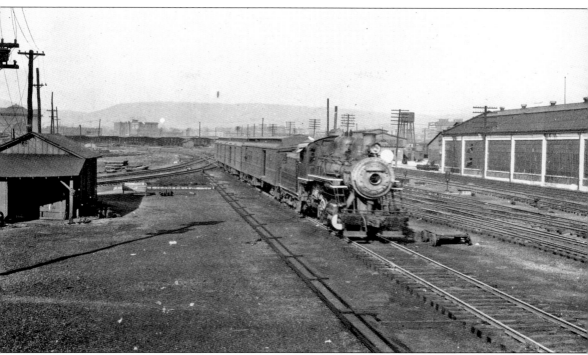

Taken from Terminal Tower looking west, this picture is one of the earliest known photographs of a train inside the terminal trackage. Southern Railway locomotive No. 1735 eases its Birmingham-bound train in reverse to access the platforms. Southern Railway's car shop can be seen on the right. (Courtesy of David Steinberg.)

Excitement abounded in the local Chattanooga papers as the opening of the station approached. The contractors building the terminal took advantage of the public's enthusiasm by placing advertisements. Here the manufacturer of the bricks used in the station advertises in the *Chattanooga News*. The bricks used in Terminal Station originally were meant for a roadway whose contract was cancelled after the bricks were made. (Courtesy of the University of Tennessee at Chattanooga Lupton Library.)

This is the earliest known photograph of the station after its opening in 1909. Hotel Street (Fourteenth Street today) can be seen on the right. This was where freight, express, and postal service pickups and deliveries could be made. Also note the streetcar tracks on Market Street in the foreground. (Courtesy of the Chattanooga–Hamilton County Bicentennial Library.)

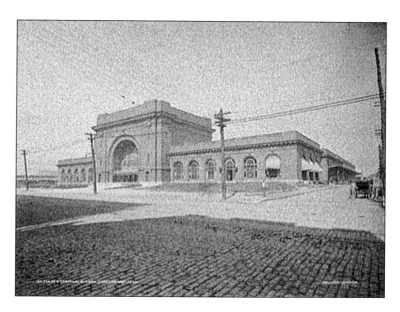

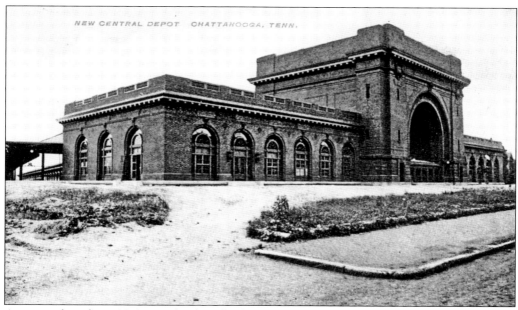

A postcard made in 1910 mistakenly calls the new station Central Depot instead of Terminal Station. This postcard does show a little-known entity. At the far left, where the entrance to one of the platforms can be seen, a metallic sign above the concourse gate can be seen. These were the original cast iron gate markers and were recently discovered in the attic at the Chattanooga Choo Choo. (Courtesy of the Chattanooga–Hamilton County Bicentennial Library.)

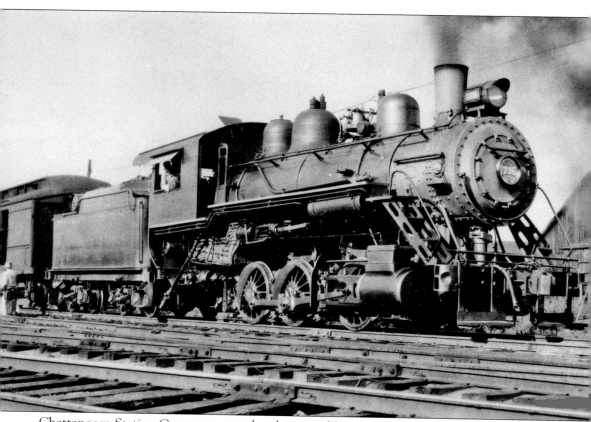

Chattanooga Station Company, owned and operated by the Southern Railway, served as the operator of Terminal Station. The company owned several steam, and eventually diesel, switching locomotives to sort passenger and express equipment within station grounds. Here switch engine No. 1736 works on July 22, 1931, shoving a railway post office car. (Courtesy of David Steinberg.)

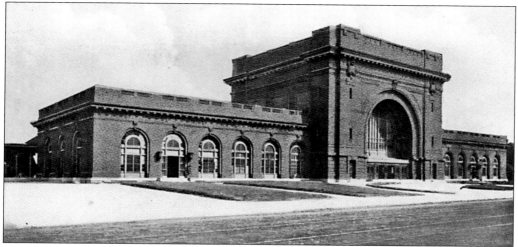

This postcard features the station just prior to opening. The door shown open in the north wing is the primary entrance to the restaurant and barbershop. This order-off-the-menu restaurant was open the entire history of the station except for the last few years. The six-chair barbershop was opened and maintained for the majority of the station's life by B. F. Stansbury. (Courtesy of the University of Tennessee at Chattanooga Lupton Library.)

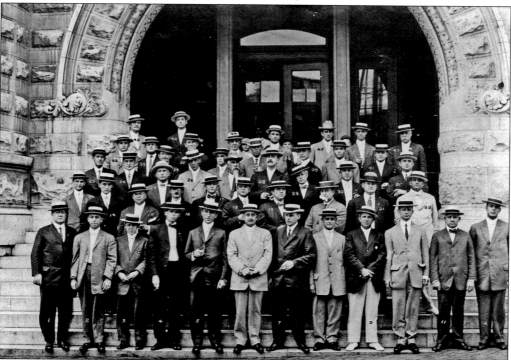

The employees of the passenger department gather together on July 3, 1911, on what can only be surmised as a Fourth of July celebration. These employees comprise the ticket agents, baggage handlers, track repairmen, clerical workers, and other positions within the station. Many of these workers may have worked the day the station opened, since the photograph was taken less than two years later. (Courtesy of David Steinberg.)

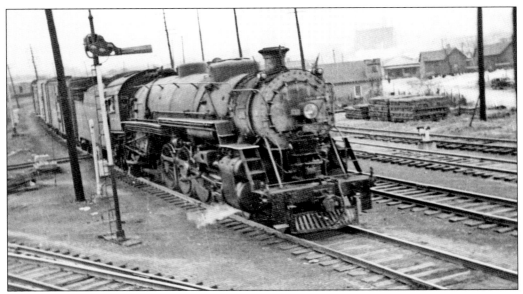

One of the last obstacles faced by the Southern Railway when they opened Terminal Station was the crossing of a rival railroad, the Nashville, Chattanooga, and St. Louis Railroad (NC&StL). The passenger lead tracks coming into the station can be seen in the lower left corner. Here an NC&StL train is heading south towards Atlanta. (Courtesy of David Steinberg.)

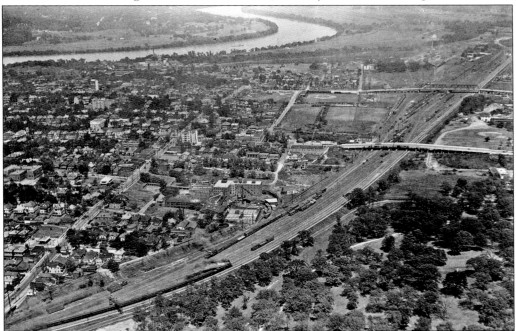

This aerial photograph shows a Southern Railway passenger train coming onto the main line from Terminal Station. Tracks to the right of the train belong to the NC&StL, and the left tracks are leads to Citico Yards. Two Chattanooga landmarks can be seen from this view: the National Cemetery in the bottom right corner and the Tennessee River in the upper left. (Courtesy of the Chattanooga–Hamilton County Bicentennial Library.)

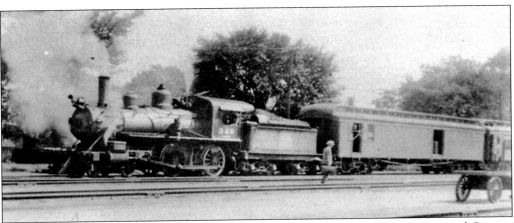

The Central of Georgia Railway was a tenant of the Southern Railway at Terminal Station during the years it provided passenger service to south Georgia. It served Chattanooga from a rail line that extended just east of the Alabama state line, between Chattanooga and Macon. Here Chattanooga train No. 1 is seen at Griffin with locomotive No. 349 waiting for a connecting train to arrive. (Courtesy of David Steinberg.)

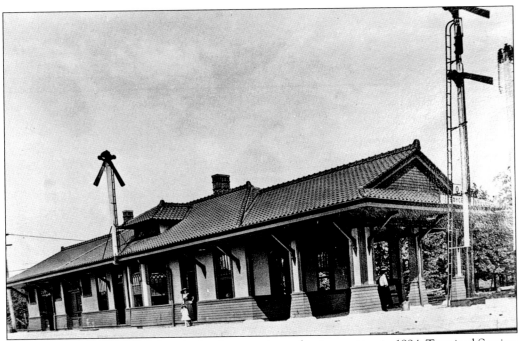

The Southern Railway built hundreds of new stations after its creation in 1894. Terminal Station was one of the largest, but other depots in the Chattanooga area were built during this time. Boyce Station served a suburb of Chattanooga and was the first station east of Terminal Station. (Courtesy of the Chattanooga–Hamilton County Bicentennial Library.)

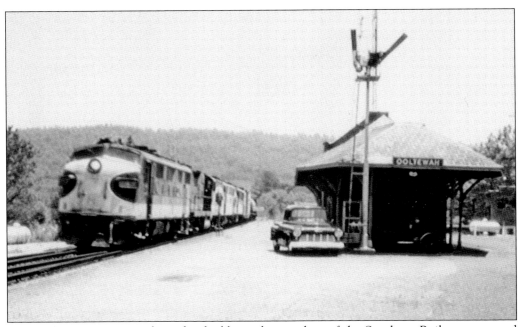

Ooltewah, Tennessee, is where the double-track main line of the Southern Railway separated to travel south to Atlanta or northeast to Knoxville. This interlocking continues to be a busy junction point today. Here a diesel-led freight train coming from Knoxville makes its way past the Ooltewah depot toward Chattanooga. (Courtesy of David Steinberg.)

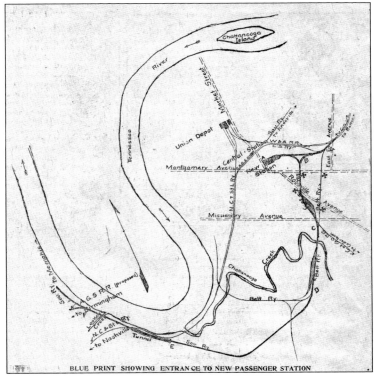

BLUE PRINT SHOWING ENTRANCE TO NEW PASSENGER STATION

This hand-drawn blueprint provides a detailed overhead view of the position of main-line tracks within the Chattanooga city limits. The new track built specifically for access to Terminal Station is seen in bold. Notice the proposed "Stevenson Extension" toward Memphis in the bottom left corner, near Lookout Mountain tunnel. (Courtesy of the Chattanooga–Hamilton County Bicentennial Library.)

Three

CONTROVERSY SURROUNDING CONSTRUCTION

Officials from the City of Chattanooga began the process of closing some local streets on the station's property to prepare for the track laying and terminal construction. This very simple measure, which should have passed through the government process with ease, was the beginning of an enormous battle involving the City of Chattanooga, some citizens of the Southside (the area surrounding the new station), and the Southern Railway. During the two years of construction, the Southern would threaten to abandon the station on three separate occasions due to the inability to reason with the local citizens over the laying of additional tracks over adjacent streets, namely Main Street and Rossville Avenue. The railroad explained that these new tracks would not be blocked for any extended period of time, only long enough for the trains to complete a reverse move needed during the turnaround procedure entering and leaving the station. The railroad agreed to install manual crossing gates at each intersection that would be manned 24 hours a day. Despite this, citizens argued that their real estate would lose value and that the railroad would create the same congestion and danger that occurred on Market Street. This came to a culmination on January 14, 1909, at a city council meeting where representatives from the Southside and a legal representative from the railroad came to finalize the decision of laying the additional tracks over the roads. At this meeting, the railroad's representation withdrew the request for all ordinances. When asked why by a local reporter, railroad attorney Ed Watkins replied "The railroads feel that because of the antagonistic spirit worked up by the Southsiders that it would be a waste of time and energy to attempt to push the ordinances through the council." When asked if this meant postponement of the station's opening date or even abandonment he replied, "I don't know. I have only done as I have been instructed by my superiors." With the railroad once again threatening to abandon a mostly finished station, local business owners and other station proponents were able to gather 300 signatures on a petition in three days supporting the railroad's need to cross the streets at grade. Still, six months would pass until the bickering among the city council, the railroad, and the Southsiders would subside, with all parties realizing that the only solution was to allow the grade crossings.

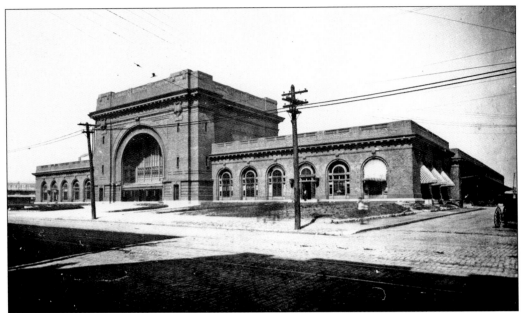

The next series of photographs shows slight alterations taking place over a 20-year period starting in the early 1920s. Terminal Station never underwent any major expansion or exterior renovations during its 61-year history, but subtle exterior changes did take place. This picture shows the cobblestone street as well as the oversized round awnings on the south end. (Courtesy of David Steinberg.)

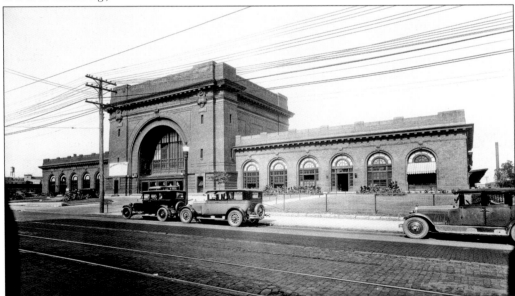

By 1933, the rounded awnings have given way to square, striped canvas awnings. The streets have seen an improvement from cobblestone to standard brick. Chattanooga's rapid growth can be seen just by the additional power and telegraph lines strewn down Market Street. Notice the light post and metal guardrails that were recently installed. (Courtesy of the Chattanooga–Hamilton County Bicentennial Library.)

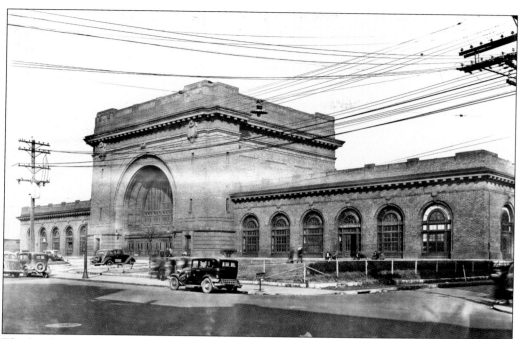

The brick streets have given way to pavement. Curb streetlights have been augmented with overhanging lights above the road. The awnings have been completely removed and the fencing repainted. Power lines are even more abundant, and transformers have been installed. However, the landscaping seems to be in need of some upkeep. (Courtesy of David Steinberg.)

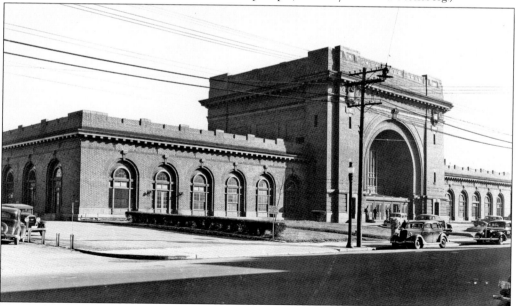

New and updated telephone lines have cut down on the amount of wires on the telephone and power poles. The landscaping is now being kept up. One addition that perhaps speaks of some issues the station may have been having is the no trespassing or loitering sign near the corner. (Courtesy of the Chattanooga–Hamilton County Bicentennial Library.)

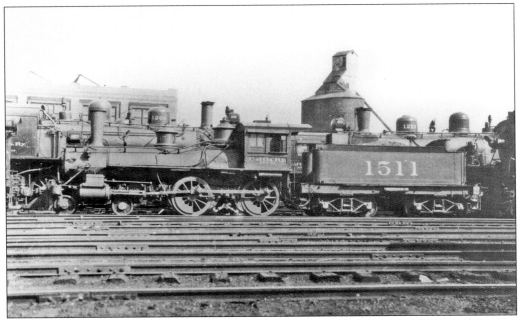

Steam locomotives of almost every style and configuration traveled the rails of Terminal Station. The following photographs present some examples. This photograph is of Central of Georgia No. 1511 in Macon, Georgia. This 4-4-0 wheel arrangement dates back to antebellum times and, depending on wheel size, could haul passengers or freight. (Courtesy of David Steinberg.)

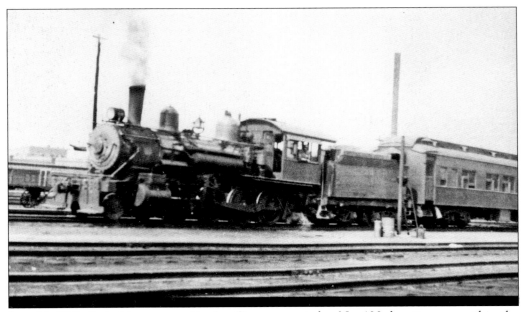

June 24, 1925, finds Chattanooga Station Company switcher No. 100 shunting cars within the terminal tracks. This 4-6-0 locomotive had excellent traction for its size, allowing it to pull heavy or long trains at a slow but steady speed. This was one of several steam locomotives employed by the station for switching duties. (Courtesy of David Steinberg.)

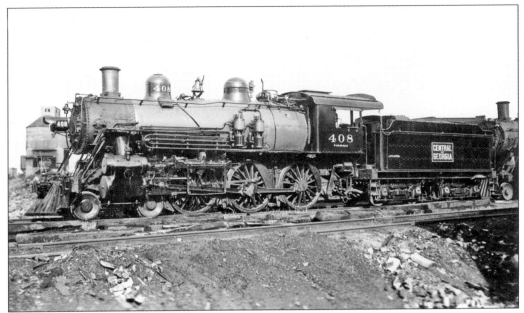

Central of Georgia No. 408, a Mogul type, has the same 4-6-0 wheel arrangement as Chattanooga Station Company No. 100. However, this locomotive had larger driving wheels beneath the engine. Larger driving wheels enabled locomotives to reach higher speeds, but they were not able to pull as much tonnage. (Courtesy of David Steinberg.)

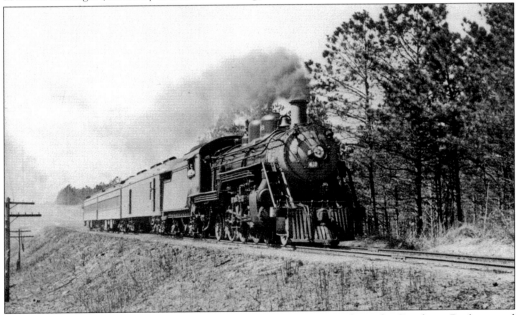

Local passenger trains were important to the small communities along the Southern Railway and Central of Georgia main and branch lines. Local trains stop at every station, sometimes even at flag stops, where someone waves down a train in order to board. Every line leaving Chattanooga at one point or another was served by one or more locals daily. Here is a local led by a high-speed 4-6-2 Pacific-style locomotive. (Courtesy of David Steinberg.)

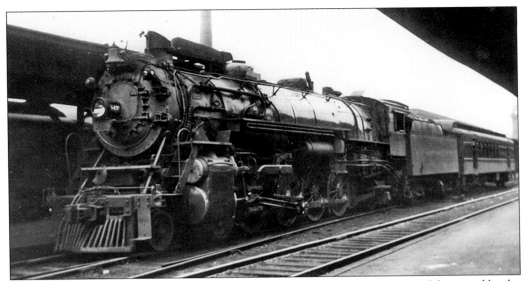

The largest locomotives to operate out of Terminal Station were the massive 4-8-2s owned by the Southern Railway. A subsidiary of the Southern Railway, the Cincinnati, New Orleans, Texas, and Pacific Railroad, operated these through the mountain grades to Cincinnati. The photograph is of engine No. 6471 at Terminal Station in March 1946 getting ready to pull the first section of the *Royal Palm* northbound. (Courtesy of David Steinberg.)

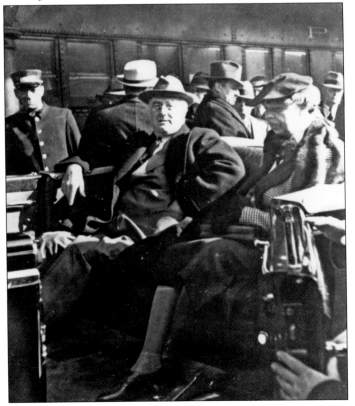

Pres. Franklin Delano Roosevelt and First Lady Eleanor Roosevelt are pictured at Terminal Station in 1940. The president was in town to dedicate Chickamauga Dam, one of the first major projects of the Tennessee Valley Authority. This is a rare photograph, as it shows the president's legs exposed in a sitting position. Due to his contraction of polio, the secret service discouraged photography of the president in this pose. The photograph only exists today because the photographer was a young boy at the time and was permitted to join his father (a newspaper photographer) on the platform. That boy later became a member of the maintenance team at the Chattanooga Choo Choo. (Courtesy of the Chattanooga Choo Choo.)

Four

PASSENGER FACILITIES AT TERMINAL STATION

The design of Terminal Station concentrated on passenger convenience. Some stations built in this era, especially in the northeast, were difficult to navigate. Even finding the main entrance through all the giant pillars of Roman architectural design could be quite a task. With Terminal Station, there was no doubt where the entrance was: beneath the enormous brick arch. At the main entrance were two rows of five sets of doors each. As of the early 21st century, the second rows of doors are original to the station, hand-carved examples of the exquisite craftsmanship of the carpenters and woodworkers who made them. When entering the station proper, passengers could see everything they might need before boarding their trains. The main waiting room was 62 by 82 feet. Twelve quartered oak benches, which could seat up to 300 passengers, commanded the center of the domed lobby. Looking up into the 85-foot-high dome, one would see four brass chandeliers, each with 40 lamps and an 18-inch opal globe in the middle. These chandeliers could produce 1,892 candlepower. They mysteriously disappeared after a false ceiling was put in place in the early 1960s to conserve heat. To the immediate right was the entrance to the Ladies' Retiring Room, some 26 by 40 feet, with restroom facilities, a waiting room, and a powder room. To the left was the Men's Smoking Room, some 34 by 42 feet, with a large washroom and a barbershop with six chairs ready for any shaving or haircut needs of the gentleman traveler. The ticket counter, located on the south wall of the waiting room, was manned by two to six agents. The Pullman Company had a separate ticket counter and agent. In the center of the north wall of the station was a hallway leading to the dining room. The restaurant was furnished with 12 English-style tables, each able to seat six patrons. The tables were built by a then-famous Chattanooga furniture manufacturer, Loomis and Hart Company. In addition to the main restaurant, there was a lunchroom located between the concourse, the hallway extending from the waiting room to the restaurant, and the waiting room itself. This was a very busy spot, as passengers who were on trains without food service would be encouraged by the conductors on board to disembark, hurry to the counter for lunch, and get themselves back on board before departure. This lunchroom was popular not only with passengers but with local Chattanoogans as well. It remained open until March 1970. In the northeast corner of the waiting room was a large newsstand, initially operated by the Parker Railway News Company of Macon, Georgia. In later years, the famous Union News Company took over operation of not only the newsstand but also the lunchroom and dining room at Terminal Station. Located directly in the middle of the row of doors leading to the concourse from the main waiting room was an information bureau. Information such as arrivals and departures could be obtained at this desk during daytime and early evening hours. A schedule board in the concourse was maintained and updated around the clock.

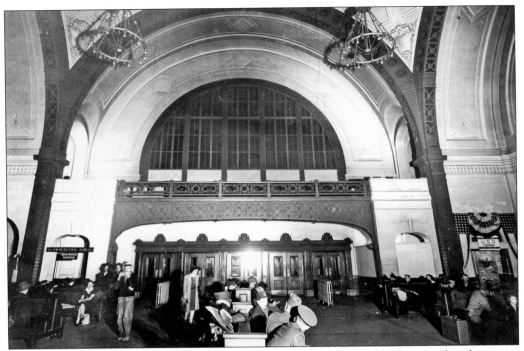

World War II created a surge of passenger traffic at both of Chattanooga's major railroad stations. In this photograph, the Men's Smoking Room has been converted to a USO lounge. To the left is the Travelers Aid office. Above are two of the four chandeliers that once adorned the waiting room ceiling. (Courtesy of David Steinberg.)

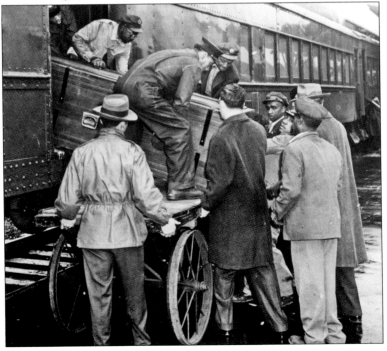

One of the most somber moments in Terminal Station's history was when the body of "The Tennessee Nightingale," Grace Moore, was brought back to Chattanooga for burial. She was a famous actress and Metropolitan Opera singer of the 1930s and 1940s. In 1947, she perished in a plane crash over Copenhagen, Denmark. She is buried in a local cemetery near the Incline Railway in Chattanooga. (Courtesy of the author.)

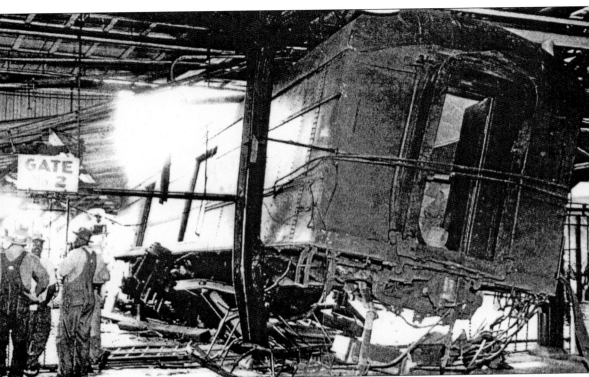

On July 17, 1953, the *Birmingham Special* overshot the platform on track No. 9. The tail end of the train, which consisted of a baggage/express car, climbed over the bumping post and crashed through the gates and partially into the concourse itself. The station suffered only minor damage to one support beam. Only one injury was reported: a Ms. Washington of Cincinnati, who sprained her ankle while running from the derailment. The train, relatively undamaged, uncoupled the rear car and was able to continue its journey only an hour late. (Courtesy of the author.)

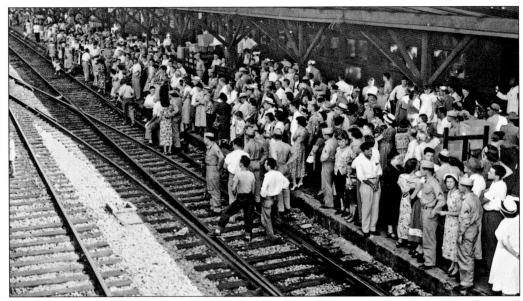

On September 4, 1950, Terminal Station once again hosted a scene that was repeated several times throughout its history. A large group of marines and well-wishers await the arrival of a Southern Railway train to begin the journey to Camp Pendleton in California. Notice the baggage carts filled to the top waiting to be off-loaded. (Courtesy of the Chattanooga–Hamilton County Bicentennial Library.)

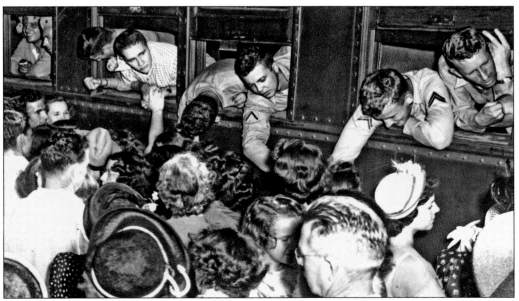

Just prior to the train departing, the family and friends of the marines on board say their final good-byes. Especially during both world wars, entire trains would be made up of troops and supplies for the war effort. In the 1950s, military personnel would travel with the general public. (Courtesy of the Chattanooga–Hamilton County Bicentennial Library.)

After World War II, Terminal Station began to feel the affects of passenger decline. Fewer and fewer people were traveling by train, instead choosing to fly or drive. Railroads countered by debuting better, faster, and more modern service. Here the Southern Railway advertises their winter season's only train, the *New Royal Palm*. (Courtesy of the Chattanooga–Hamilton County Bicentennial Library.)

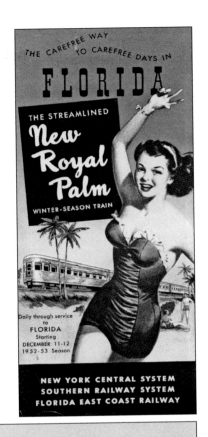

The final page in an advertising pamphlet directed towards business travelers depicts a homecoming between a man and his "best friend." By the mid-1950s, businessmen were attracted by the ever-growing convenience and speed of air travel, so every effort was made to keep their business. (Courtesy of the Chattanooga–Hamilton County Bicentennial Library.)

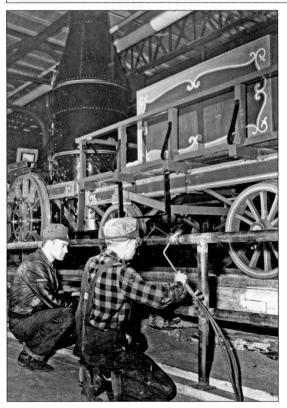

Families were also a large source of revenue for the passenger railroads. The Southern Railway for years had programs and incentives for kids of every age. One of the programs kept until the end of passenger service was the Junior Railroader. (Courtesy of the Chattanooga–Hamilton County Bicentennial Library.)

The *Best Friend of Charleston* was the first locomotive to pull a regularly scheduled passenger train in the United States. This service, which began in the early 1830s, later became part of what was to be known as the Southern Railway. As part of its heritage, the Southern permitted a replica of the *Best Friend* to travel around the railroad and be put on display for the public, as seen here at Terminal Station. (Courtesy of the Chattanooga–Hamilton County Bicentennial Library.)

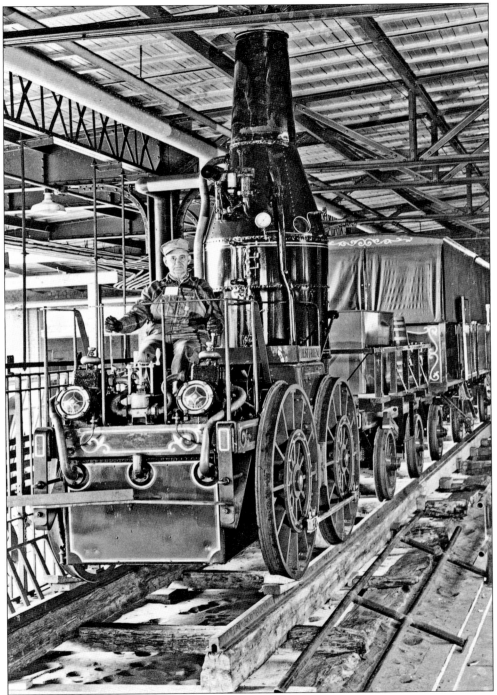

George W. Pylant, a diesel locomotive engineer, pretends to be at the controls of the *Best Friend of Charleston*, on display at Terminal Station. The locomotive is located at the northernmost end of the train concourse but is kept out of the weather under the shed. (Courtesy of the Chattanooga–Hamilton County Bicentennial Library.)

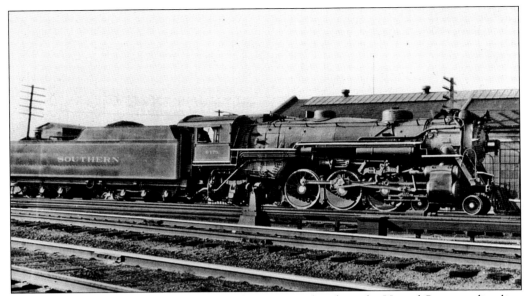

The Southern Railway became one of the first major railroads in the United States to dieselize. The Chattanooga area, however, was one the last bastions of steam engines on the railroad. Here one of the Southern's famous PS-4 high-speed passenger locomotives makes its way through the terminal tracks to the roundhouse to be serviced. (Courtesy of David Steinberg.)

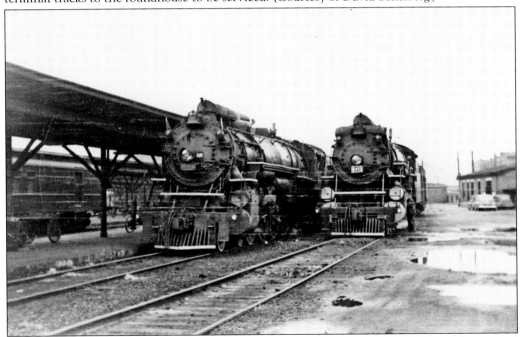

In March 1946, two locomotives of the Southern's subsidiary Cincinnati, New Orleans, and Texas Pacific Railway (CNO&TP) Nos. 6499 and 6471, occupy tracks 1 and 2 awaiting their next assignments. Locomotives sometimes were kept "on call" for any issues with the regular power on passenger consist. Track 1 was the only one of 14 not to have a platform attached at Terminal Station. (Courtesy of David Steinberg.)

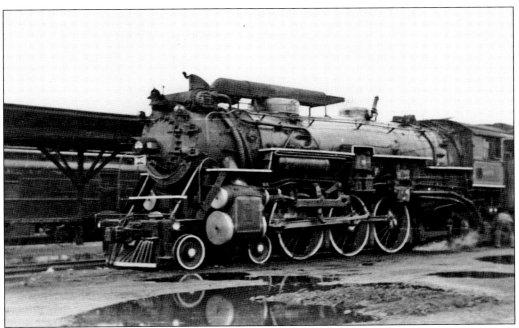

A steam locomotive assigned to the CNO&TP division of the Southern can be easily recognized by the large smoke deflector mounted on top. This deflector was used to direct smoke across the top of the cab and away from the engineer and fireman while pulling through tunnels. The CNO&TP was known for its tough grades and numerous tunnels between Chattanooga and Cincinnati. (Courtesy of David Steinberg.)

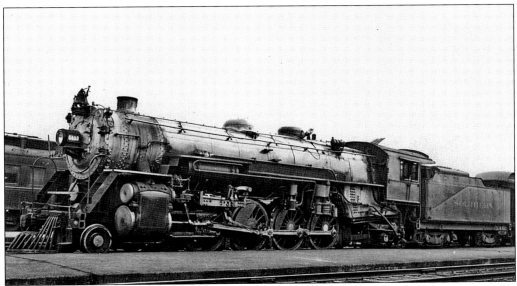

In April 1932, Southern Railway No. 6493 readies itself on track 7. This large locomotive was the predecessor to the ones used on the CNO&TP division with smoke deflectors. Large locomotives such as this were able to move trains with heavyweight cars over mountain grades at speed. (Courtesy of David Steinberg.)

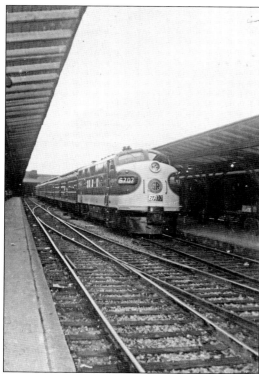

The Southern Railway eliminated all steam locomotives from regular service in 1953; however, passenger service was the first to convert to diesel. In this photograph from April 16, 1953, a local is seen with a brand-new or recently serviced cab unit on the front end. (Courtesy of David Steinberg.)

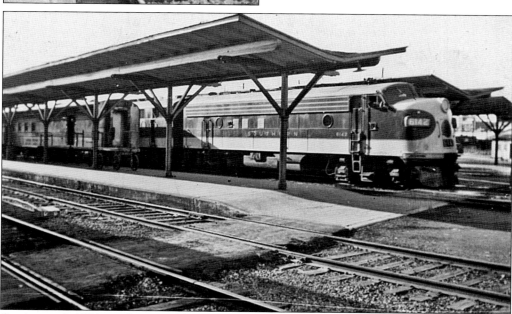

On August 3, 1954, another set of diesel engines off-load passengers while a railway post office car (RPO) is serviced on the adjacent track. The pathway in the foreground is for the baggage carts to be carried across the tracks to access the baggage cars, most of which were located toward the front of arriving trains. Remnants of the baggage cart crossings can still be seen at the Chattanooga Choo Choo. (Courtesy of David Steinberg.)

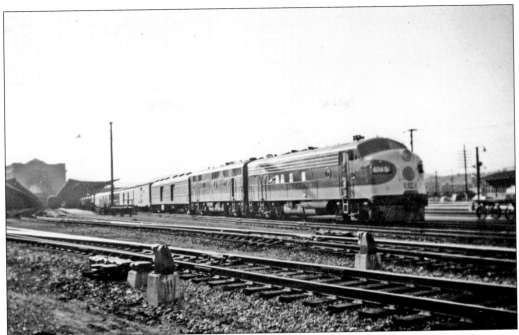

Train No. 41, the *Pelican*, is shown stopped at Terminal Station on April 16, 1953. This is an excellent view down the length of the platforms. In the foreground are the signals and switches that guard the tracks ahead as they combine coming towards Terminal Tower. (Courtesy of David Steinberg.)

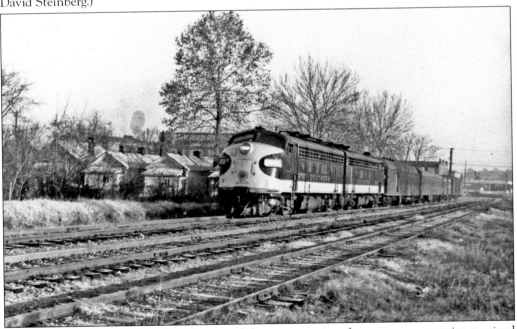

The same diesel locomotives that eliminated the steam engines from passenger service survived long enough to see their own trains discontinued. On November 30, 1969, the last train No. 3 arrives in Chattanooga on its way into Terminal Station. (Courtesy of David Steinberg.)

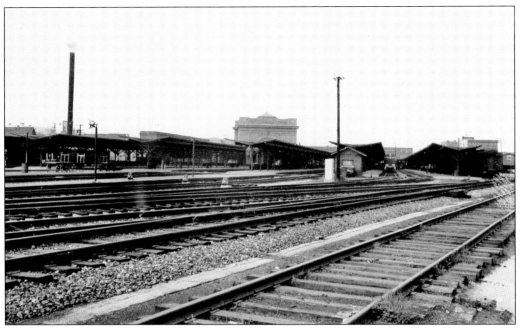

On July 20, 1956, Terminal Station seems quiet for the time being. The track in the immediate foreground leads to the Central of Georgia freight station and office. The smokestack looming in the background is part of the boiler house for the station. (Courtesy of David Steinberg.)

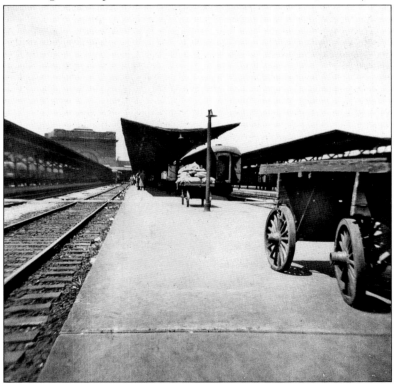

On April 17, 1953, the northbound *Pelican* is loaded with baggage, express, and passengers. Notice the locomotives are missing, as during this layover period, the engines are detached from the trains and serviced with water, sand, and fuel. (Courtesy of David Steinberg.)

A rainy July 3, 1953, welcomes the *Pelican* arriving on track 9, behind schedule by 10 minutes. Connections in Chattanooga were provided between the *Pelican* and the *Birmingham Special* to points south such as Birmingham, Meridian, and New Orleans. (Courtesy of David Steinberg.)

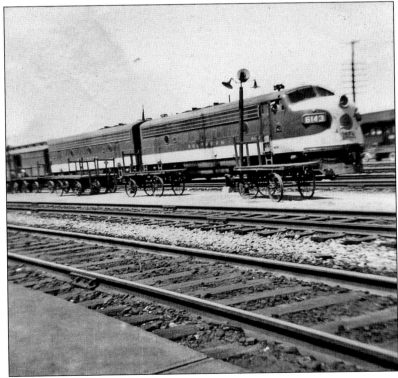

Train No. 4 has arrived on April 18, 1953, and begins several switching maneuvers for the baggage and express cars. Here the locomotives have just stopped briefly while unloading the cars. They will soon pull ahead and then back into their train, ready to depart for Cincinnati. (Courtesy of David Steinberg.)

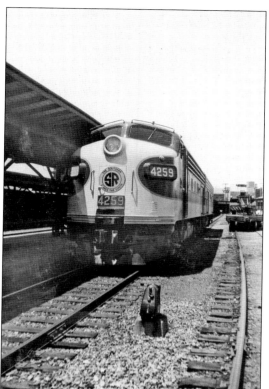

A set of diesel locomotives sits idle but ready for service on July 20, 1956. This scene is similar to earlier photographs from the steam era of backup locomotives in the same location on tracks 1 and 2. (Courtesy of David Steinberg.)

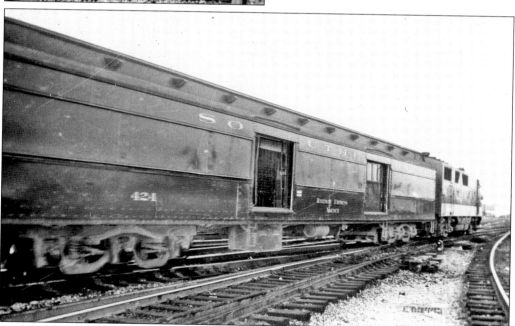

Train No. 36 arrives on track 3 on August 3, 1953. This is an excellent photograph of a heavyweight express and baggage car. Notice the door is already open, ready for the rapid discharge and intake of baggage. (Courtesy of David Steinberg.)

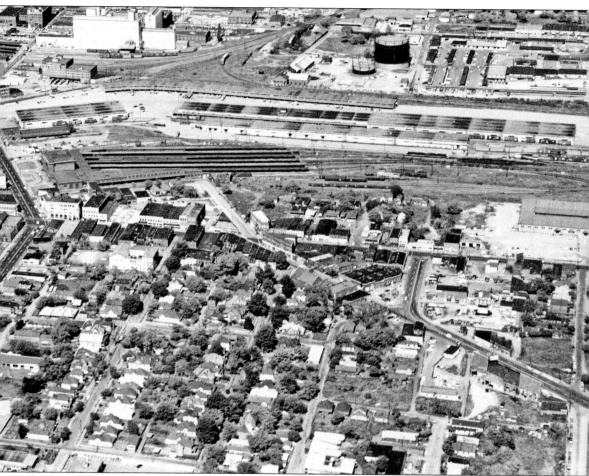

An aerial view of Terminal Station from 1955 shows the developing industry beginning to surround it. A food warehouse and transfer facility has been built where the former shops and roundhouse of the CNO&TP were located. A close look reveals two diesel engines being serviced at the fuel pad. (Courtesy of the Chattanooga–Hamilton County Bicentennial Library.)

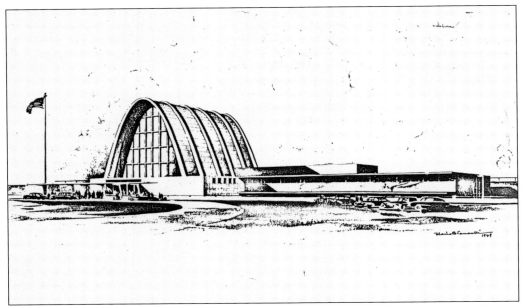

In 1947, the Chattanooga Terminal Authority was formed to explore the potential of combining Union Station and Terminal Station into one shared facility. By 1949, several plans were submitted, including this modernistic structure. This design, while keeping the spacious waiting room, looks very similar to an airport terminal. (Courtesy of David Steinberg.)

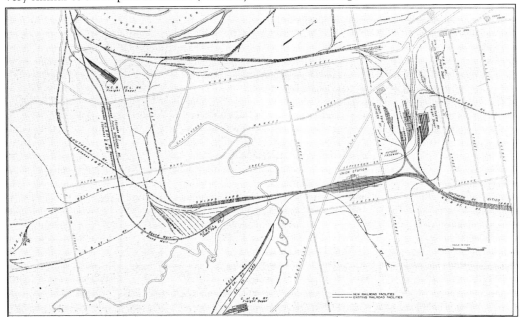

The Chattanooga Terminal Authority also explored the removal of all downtown railroad tracks, relocating them via under/overpasses away from the business district. The final plan shown here never came to full fruition. The new station was never built and the NC&StL tracks were relocated west of the location on the map. (Courtesy of the Chattanooga–Hamilton County Bicentennial Library.)

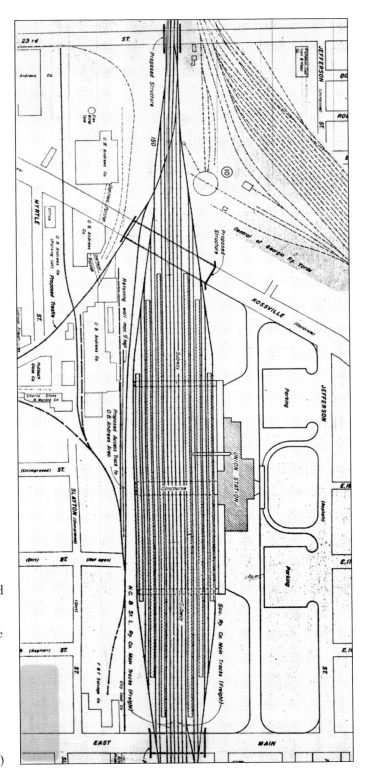

The plans for the never-built Union Station show how platform tracks would have been accessed by underground passageways. This allowed both the Southern and NC&StL Railroads to operate freight trains through the station facility without danger or interference from passenger trains. Each railroad could also be served from its respective side of the station. (Courtesy of the Chattanooga–Hamilton County Bicentennial Library.)

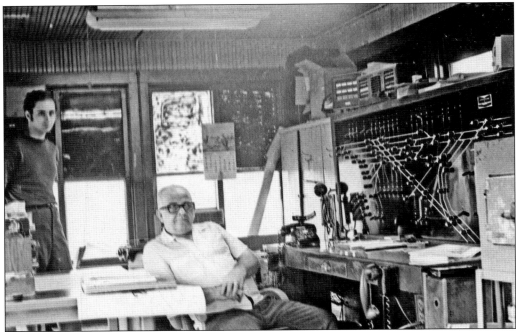

Operator Waller sits at his post in the second story of Terminal Tower. The control board in front of him can operate any switch and signal within Terminal Station's territory. The following photographs depict the progress of a train departing Terminal Station. (Courtesy of David Steinberg.)

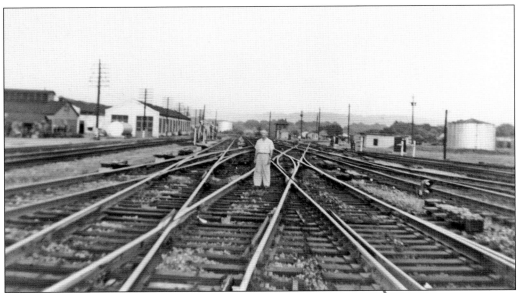

When a train received a clear signal from the tower, all the switches had been aligned for the movement necessary for that particular train. Generally the trains had backed in to allow a quick departure. Here the head baggage master is seen inside the interlocking, where trains could proceed straight to go east or to the right of the tower to go west. (Courtesy of David Steinberg.)

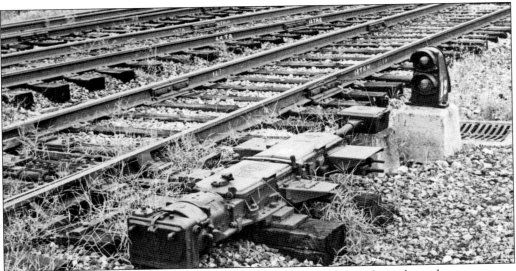

A close-up photograph of the dwarf signal and switch machines shows how the system was automated. Each signal and switch was numbered and corresponded with the dispatching board inside Terminal Tower. Prior to a major upgrade of the interlocking plant, each switch had to be manually thrown utilizing levers inside the tower. (Courtesy of David Steinberg.)

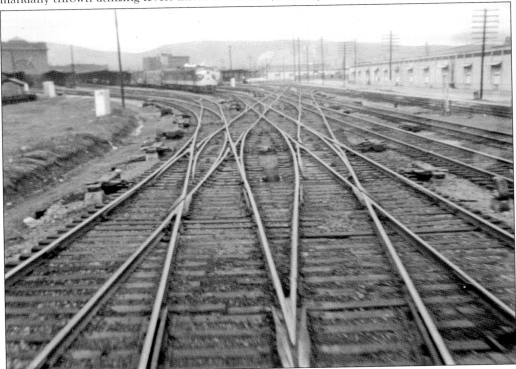

The back end of a train clears the first set of switches as it leaves the station. These switches are called double-slip turnouts, as they allow either track on each side to align for either opposing track. The white boxes on the left are the cabinets that protect the electrical components of the interlocking plant. (Courtesy of David Steinberg.)

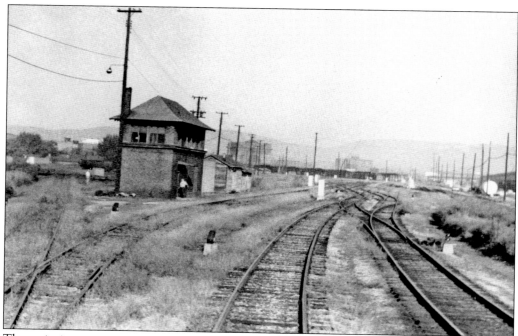

The train is now passing Terminal Tower. Operator Waller is seen at the bottom of the tower inspecting the train as it goes past. The track covered with weeds on the left leads to the eight-track coach yard. (Courtesy of David Steinberg.)

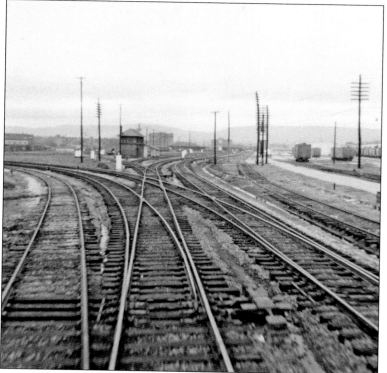

Once clear of this switch, the train is now out of the territory controlled by Terminal Tower. The tracks ahead lead to the station, while the tracks diverting to the left are a part of the passenger main line. Inbound trains would utilize them to pull forward and then reverse into the station on a separate set of tracks. (Courtesy of David Steinberg.)

On the left is East
End Tower, which
controls access to the
passenger main line.
As the train departs
the passenger main,
it enters the main
line for the Southern
Railway. (Courtesy
of David Steinberg.)

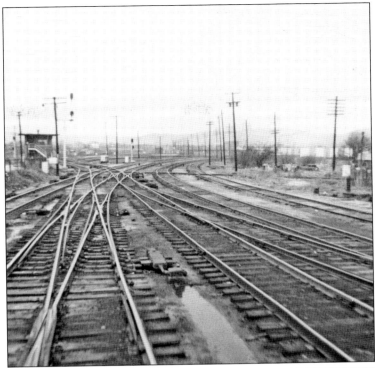

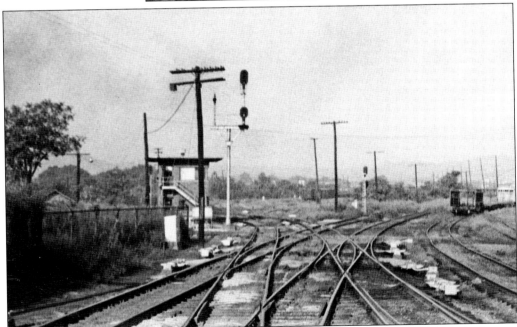

Less than 10 years have passed since the previous photograph. The east-end interlocking is beginning to deteriorate as fewer and fewer passenger trains emanate from Terminal Station. The railroad had very little incentive to keep up tracks that were soon to be abandoned with the discontinuance of passenger service. (Courtesy of David Steinberg.)

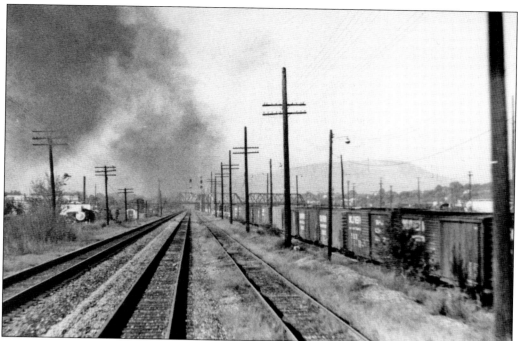

Traveling at track speed, the train has now entered the Southern's mainline, bypassing Citico Yard (now known as Debutts Yard). Lookout Mountain looms in the distance, and Terminal Station lies about 2 miles behind the train. (Courtesy of David Steinberg.)

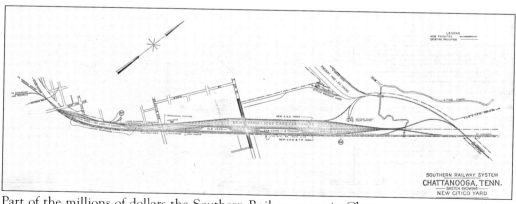

Part of the millions of dollars the Southern Railway spent in Chattanooga went to railroad facilities for passenger and freight engines. This map depicts the massive expansion of Citico Yards, including a new servicing facility and roundhouse. The larger locomotives that served Terminal Station would sometimes be serviced here. (Courtesy of the Chattanooga–Hamilton County Bicentennial Library.)

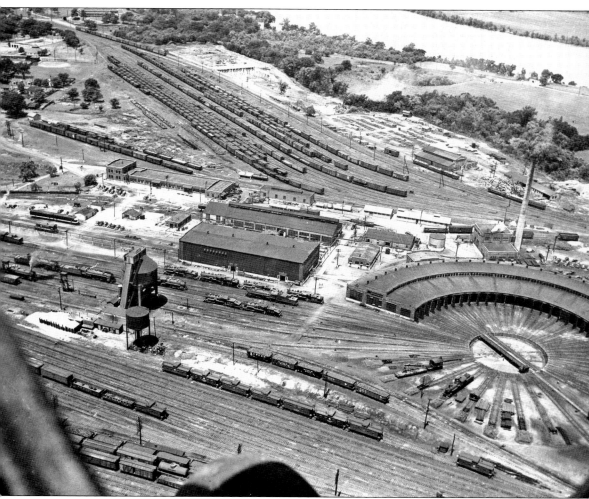

In this aerial view of the shop facilities, both steam and diesel locomotives intermingle. This was taken during the late 1940s or early 1950s, as the Southern Railway was in the process of purchasing new motive power. It was in this yard that the last steam locomotive on the Southern would operate in 1953. (Courtesy of the Chattanooga–Hamilton County Bicentennial Library.)

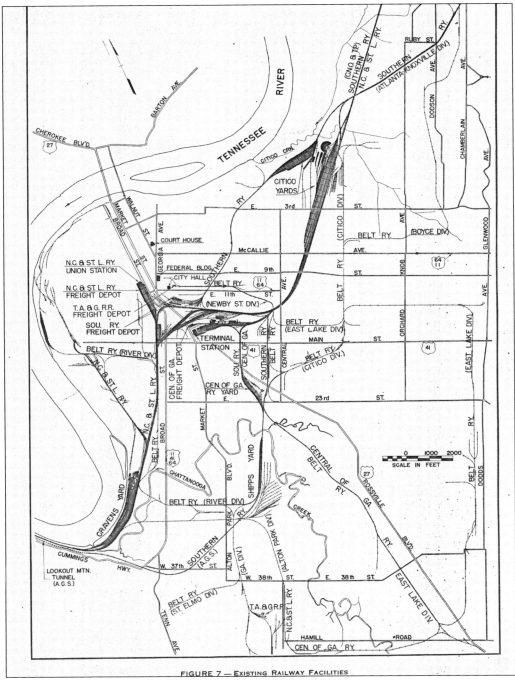

FIGURE 7 — EXISTING RAILWAY FACILITIES

This map and diagram shows every track excluding streetcar lines utilized during the heyday of rail traffic in Chattanooga. Terminal Station was located at a very strategic point for the Southern. The Central of Georgia's entrance into the station was a direct shot, as a portion of its freight yards was located on the passenger mainline. (Courtesy of David Steinberg.)

Five

Main Concourse, Baggage Room, and Express Building

Opposite the entrance across the waiting room was the main concourse, some 60 feet wide by 100 feet long. An iron fence with gates was erected to separate the passenger areas from the train platforms. This was to ensure safety of the passengers waiting as the trains were backing into the station. Once the trains arrived, passengers would disembark to eat in the lunchroom, retrieve their baggage from the baggage reception room, or catch taxis or other transportation at the end of the concourse. Once this was completed, the corresponding gate was opened, leading to the platform where the train had arrived. On the right of the concourse was the Baggage/Express Building. While considered a separate building, the concourse roofline extended over the area between the main terminal and the baggage building, creating a breezeway between the two. The baggage room was 60 by 80 feet and was located in the closest portion of the building facing the main terminal. As train traffic slowed to a trickle, the baggage room was no longer needed, and the ticket agents themselves became responsible for tagging and sorting luggage. Adjacent to the baggage room was a separate room measuring 48 by 75 feet for use by the U.S. Post Office as their sorting facility at the station. All mail leaving Chattanooga bound for routes along the Southern Railway would be sorted and bagged in this room. The rest of the building, both the ground and upper floor, was originally held by the Southern Express Company, later to be bought and renamed the Railway Express Agency (REA). Larger packages, crates, oversized baggage, and expedited shipments would be handled by the REA. On the north end of the station campus, towards the end of the concourse, was a small brick building nestled beneath the sheds of tracks 2 and 3. This structure was the stationmaster's office and maintenance area for the track workers and switch tenders. At the end of the track platforms and interlocking plant was Terminal Tower, the control point for any trains arriving or departing the station. This tower was not accessible to the general public but could be easily viewed from any passenger train while traversing the interlocking. Terminal Tower used the same construction techniques as the rest of the station, and it looked like a miniature version of the station.

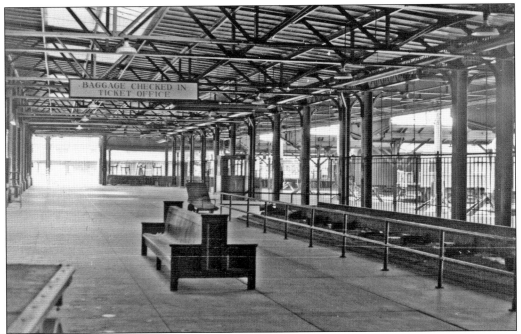

The passenger concourse has changed little over the decades. This was the view looking north after exiting the waiting room. One year after this August 1969 photograph, the station would be closed. (Courtesy of David Steinberg.)

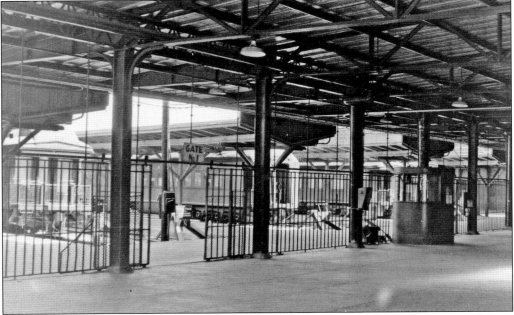

To the right in this view looking out onto the platform tracks is the little-used gateman's shanty. Much of the equipment seen on the platforms is either retired equipment of the Southern Railway or rolling stock owned by the Tennessee Valley Railroad Museum. The museum utilized the platform tracks at Terminal Station for storage during the last few years. (Courtesy of David Steinberg.)

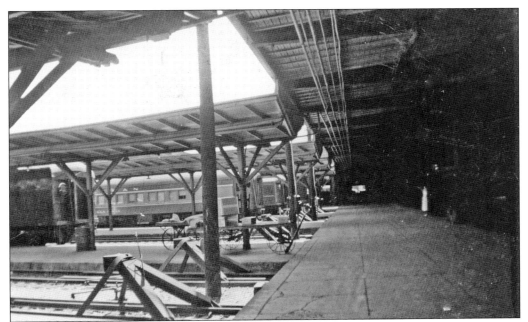

On July 20, 1956, the tracks outside the concourse look almost full, but not a single soul can be seen on the platforms. It was at this time that the discontinuance of trains began, and more and more of the tracks filled with static or little-used equipment. (Courtesy of David Steinberg.)

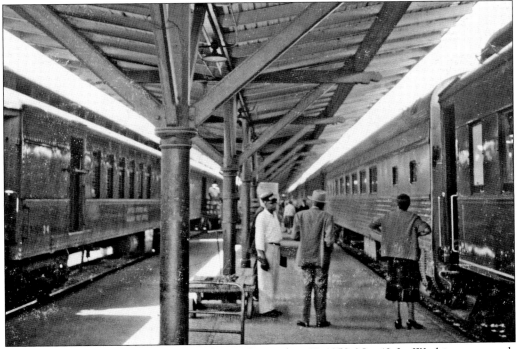

During one of the busier times of the day on September 19, 1958, No. 42 for Washington stands on track 9. On track 8 stands the *Royal Palm*, train No. 4, soon to depart for Cincinnati. One wonders what the red cap and passenger are discussing. (Courtesy of David Steinberg.)

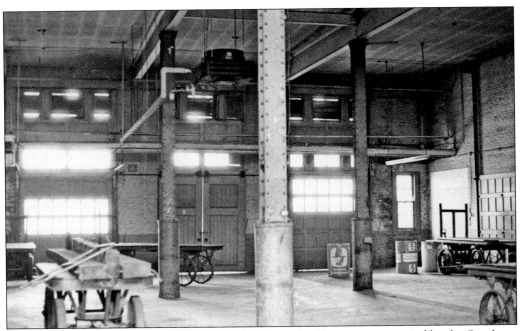

This rare photograph shows the interior of the express building, once occupied by the Southern Express Company, later the Railway Express Agency. The long, triangular, two-story brick structure occupies the south end of Terminal Station's property. (Courtesy of David Steinberg.)

RAILWAY EXPRESS

CHATTANOOGA, TENN.

DESTINATION

FROM _CINCINNATI, OHIO._ DATE JUL 8 1958 195_

R.R. _Sou_ TRAIN NO. CAR INITIAL AND NUMBER _Sou 540_

IF CAR IS TO BE WORKED ENROUTE, FILL OUT SPACES BELOW:

IF CARLOAD SHIPMENT, SHOW CONSIGNEE'S NAME BELOW:

THIS CAR TO BE WORKED AT

RAILWAY EXPRESS AGENCY

REMOVE CAR CARD WHEN CAR IS EMPTY Printed in U.S.A. (1095 8-57)

A waybill would be attached to cargo and departing mail and express that needed to be identified. The items in this car departed Cincinnati for Chattanooga on July 8, 1958, on express car No. 540. When the car was emptied at its destination, the waybill card would be removed. (Courtesy of David Steinberg.)

This tag would be attached to any baggage checked with the ticket agents or red caps. Checking bags in the early days took place at one end of the station concourse. When train schedules were cut back, the ticket agents took up the responsibilities of checking luggage. (Courtesy of David Steinberg.)

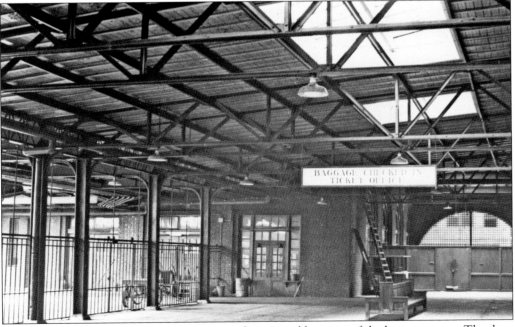

The southernmost end of the concourse was the original location of the baggage room. The door in the center of the photograph is where departing passengers would check baggage, while the opposite side of the gate is where arriving passengers would pick up their luggage. (Courtesy of David Steinberg.)

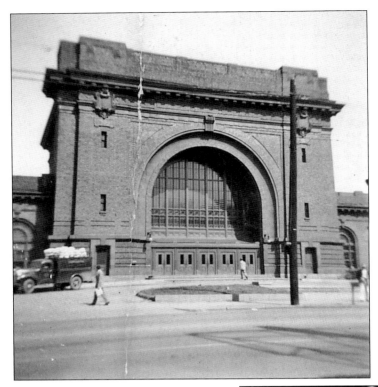

Terminal Station's entrance on Market Street looked very plain once the power lines, streetcar tracks, fencing, and almost all of the landscaping had been removed. This view on April 8, 1953, represents what the station looked like up to the day it closed. (Courtesy of the Chattanooga–Hamilton County Bicentennial Library.)

A teenage David Steinberg (right) is pictured with a Southern Railway porter on one of his many trips to New York. Steinberg's friendship with the railroaders at Terminal Station allowed him access to photograph the daily life at the station. These photographs have proved instrumental in researching the history of the station. (Courtesy of David Steinberg.)

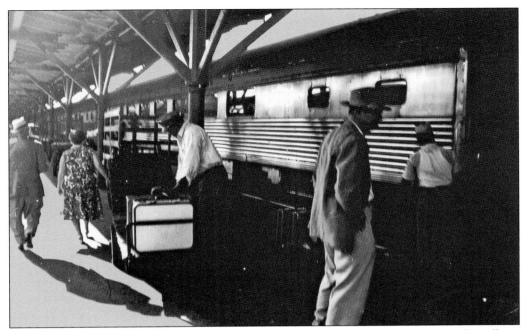

On August 3, 1954, a red cap can be seen assisting a passenger with luggage. A couple walking down the platform on the left seems to be looking for their loved ones or trying to locate their assigned coach. Scenes like this played out daily underneath the butterfly sheds. (Courtesy of David Steinberg.)

Three of the most important trains coming through Terminal Station were the *Birmingham Special*, the *Pelican*, and the *Tennessean*. All three were operated on a portion of their routes by a railroad other than the Southern. The Birmingham Special split in Chattanooga, one section for Birmingham and the other for Memphis. (Courtesy of David Steinberg.)

TABLE G — Birmingham Special
Coach and Pullman
New York-Washington-Lynchburg-Roanoke
Bristol-Knoxville-Chattanooga
Birmingham-Memphis

TABLE H — The Pelican
Coach and Pullman
New York-Washington-Lynchburg-Roanoke
Williamson-Bristol-Knoxville-Chattanooga
Birmingham-Meridian-Shreveport-New Orleans

TABLE I — The Tennessean
Coach and Pullman
New York-Washington-Lynchburg-Roanoke
Bristol-Knoxville-Chattanooga
Nashville-Memphis

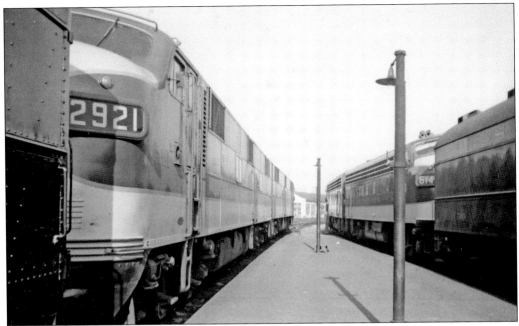

The *Royal Palm* on the left and the *Pelican* on the right share a platform on August 3, 1954. This one platform was extended in the early days of the station to accommodate the lengthy long-distance trains. Sometimes the trains would be so long they would be "doubled," meaning split in half so both halves could fit onto the platforms of a station. (Courtesy of David Steinberg.)

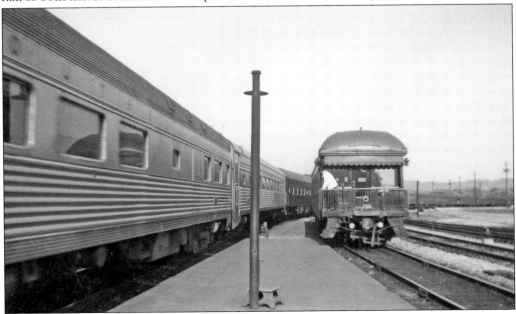

The *Pelican* departs Terminal Station on August 3, 1954, with a business car on the rear end. Private railroad car owners or railroad executives have always been able to travel in luxury aboard this style of railcar. The car's assigned porter holds on as the train rounds the curve to head west. (Courtesy of David Steinberg.)

On July 13, 1953, train No. 42 is seen backing into track 7 of Terminal Station. The conductor is on the rear platform watching the reverse movement closely. If the engineer fails to stop a comfortable distance from the bumping post, the conductor can initiate the brakes from a valve on the rear end. (Courtesy of David Steinberg.)

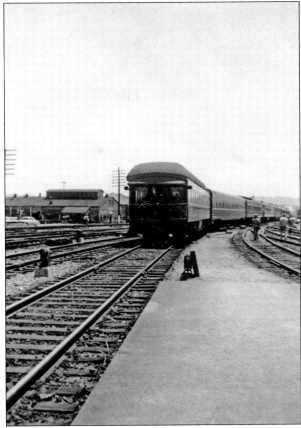

The *New Royal Palm*, streamlined and updated from the original *Royal Palm*, is shown backing into track 7. The baggage carts stand at attention near the point where the baggage car will come to a stop. (Courtesy of David Steinberg.)

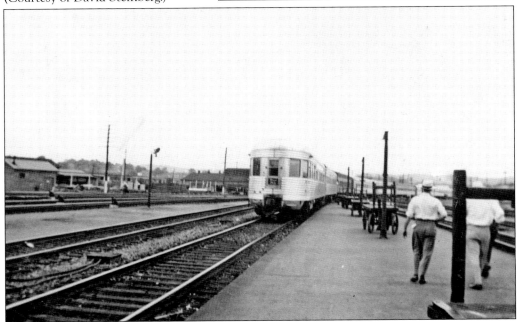

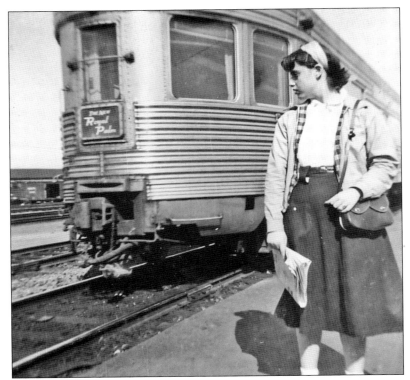

This unidentified woman does not seem to be affected by the *New Royal Palm* passing her. On the rear of the train is a round-ended observation car. Most cars of this type were utilized as lounge areas on board the train. (Courtesy of David Steinberg.)

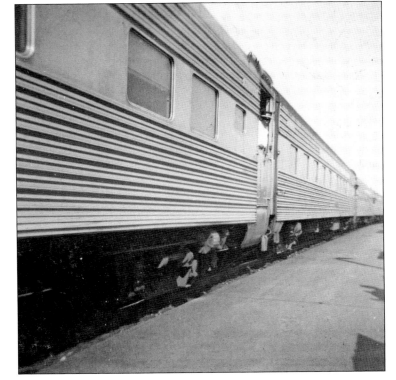

The porters assigned to these coaches stand in the vestibules ready to welcome passengers on board as the train approaches the station. These streamlined coaches featured drop-down steps to diminish wind resistance. (Courtesy of David Steinberg.)

Late in the evening on August 3, 1953, No. 18 is pictured backing into the terminal. The conductor keeps a watchful eye as the train continues backward. Observe the marker lamps on the top of the vestibule to acknowledge the end of the train. (Courtesy of David Steinberg.)

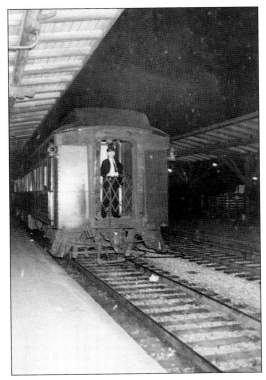

"Bud" Ivey, a car man, is seen prior to his retirement in 1959. A car man's job was to inspect the passenger consist and oil the friction bearing journals while the train was in the station. (Courtesy of David Steinberg.)

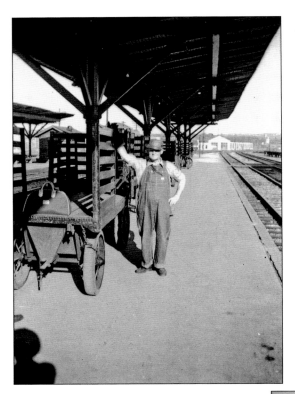

Another car man, "Pat" Patterson, strikes a pose similar to Ivey's. In the background, the car shop and refueling pad can be seen. (Courtesy of David Steinberg.)

George Heany—or to his crew simply "Boss"—retired in 1958 after decades of service on the railroad. He led his team of car inspectors at Terminal Station and befriended a young David Steinberg, thus the photographs of himself and his crew. (Courtesy of David Steinberg.)

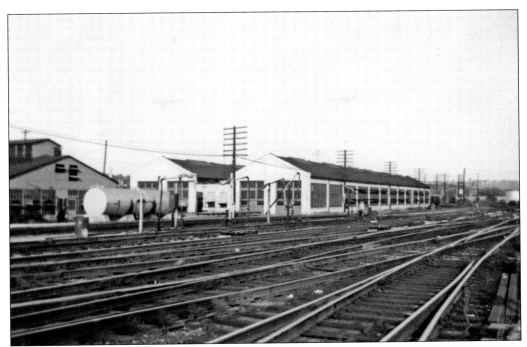

The Southern Railway car shop can clearly be seen from this view. Directly in front is the refueling pad, which could service three locomotives simultaneously. Sand for traction and water for the steam boilers in select diesels would also be filled at the pad. (Courtesy of David Steinberg.)

The switching crew for Terminal Station poses for a photograph in the mid-1950s. The only person identified in the photograph is J. H. Daughtrey, the engineer (far right). The other two are the fireman off the "extra" board and the brakeman. (Courtesy of David Steinberg.)

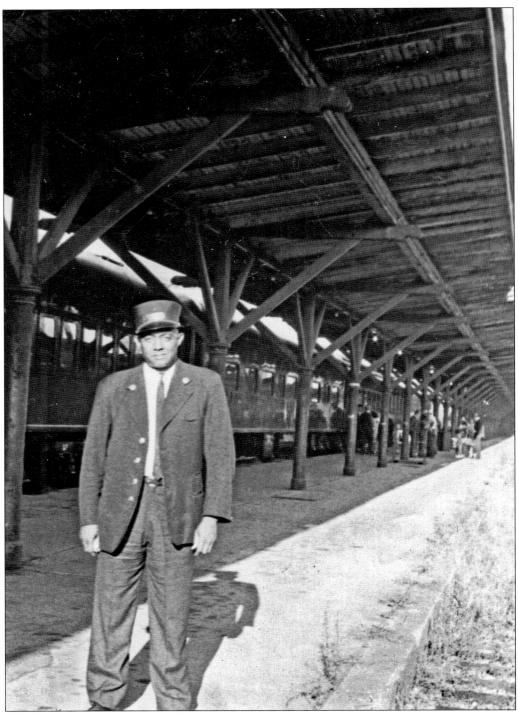

A porter for the Southern Railway poses for a picture in the afternoon sun. The weeds beginning to overrun the tracks and platform give a clue that the arrival of a passenger train at Terminal Station is becoming a rare occurrence. (Courtesy of David Steinberg.)

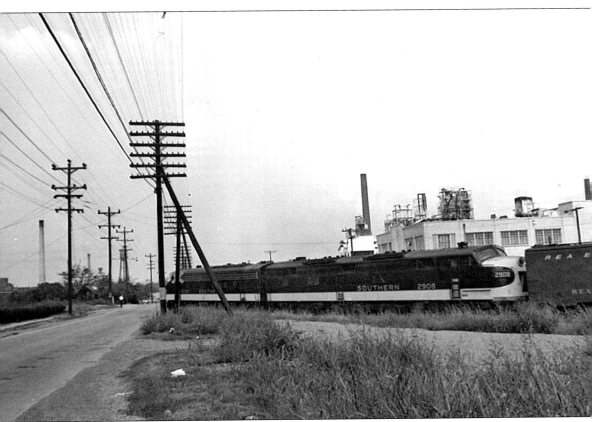

A derailment near Gadsden, Alabama, shut down the main line to Chattanooga in September 1965. To prevent massive delays or cancellations of passenger trains, the Southern Railway diverted the *Pelican* over the Tennessee, Alabama, and Georgia Railroad. This is the *Pelican* crossing over Central Avenue in Alton Park, just south of Chattanooga. (Courtesy of David Steinberg.)

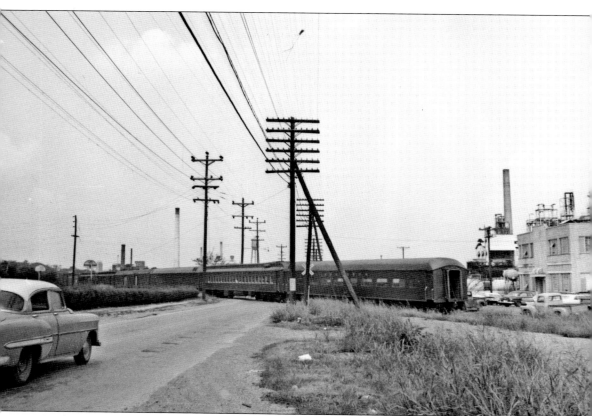

A rebuilt heavyweight passenger coach brings up the rear of a rerouted *Pelican* during the cleanup of a major derailment in Gadsden, Alabama. The Tennessee, Alabama, and Georgia Railroad, on which the train is traveling, would later be bought out by the Southern Railway and become a subsidiary. (Courtesy of David Steinberg.)

Six

PASSENGER SERVICE
DECLINES

In 1944, the last renovations were completed to Terminal Station. The war-weary building was beginning to show the toll of nearly 40 years of continuous use. The ticket office was modernized by eliminating the iron grillwork that separated the agents from the passengers. This offered a warmer and more inviting facade to the public. The Travelers' Aide office was relocated to the former information booth, then located in the doorways between the concourse and waiting room. One of the more obvious changes was to the glass on top of the dome and inside the giant brick arches. The original glass panes were completely clear, but a slightly opaque glass replaced it, helping to reduce the glare inside the waiting room. The station was completely repainted, with warm cream colors and soft green accents throughout. Skylights were installed with non-glare glass in the concourse. The USO Club, occupying the Men's Smoking Room at the time, received new paint and window treatments.

After World War II, passenger service in Chattanooga, along with the rest of the United States, saw steady decline. The use of automobiles quickly grew as the boys "over there" came home and made their first large purchases. As the Southern Railway saw its passenger ridership decline, it first began to reduce the total number of trains on its routes. If two named trains went the same route, but neither was able to meet budget needs, the train operating deepest in the red was cut, and all passengers were diverted to the other train. During the height of Terminal Station, over 60 trains were scheduled through the station. By the late 1960s, only two named trains were left, the *Royal Palm* between Cincinnati and Atlanta and the *Birmingham Special* between Birmingham and Washington, D.C., with connections to New York. When the *Royal Palm* made its last departure on December 1, 1969, Terminal Station had but one train left on the schedule board.

On a rainy evening, August 11, 1970, the final train arrived into Terminal Station. The *Birmingham Special*, also known as train No. 18, left at 11:35 p.m. with only a handful of dedicated Chattanoogans and railroad employees to witness its departure. The next day, all 17 employees at the station—laborers, baggage men, and ticket agents—were either reassigned to the freight department or took their retirement. Terminal Station was then stripped of anything the railroad could use in other departments or offices. Boarded up, with pigeons as its only tenants, it would be over a year before Terminal Station would see its first hope of a second life.

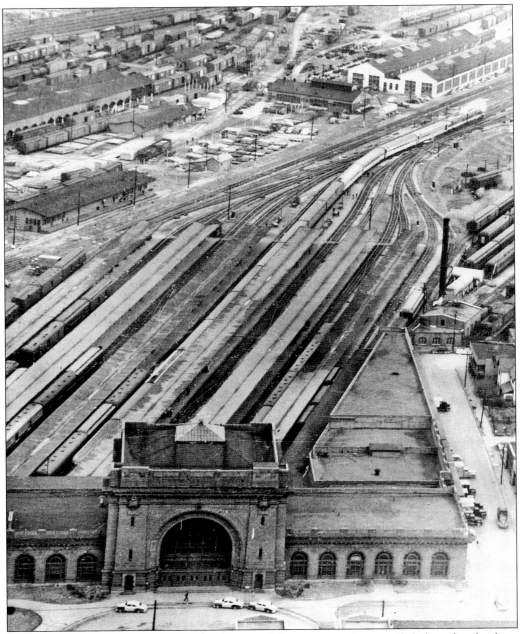

A 14-car passenger train has arrived at Terminal Station in a photograph believed to be from the mid-1950s. The slowdown of passenger traffic is evident, as most of the platforms are filled to capacity with stored cars, and so is the eight-track coach yard at the right of the photograph. (Courtesy of David Steinberg.)

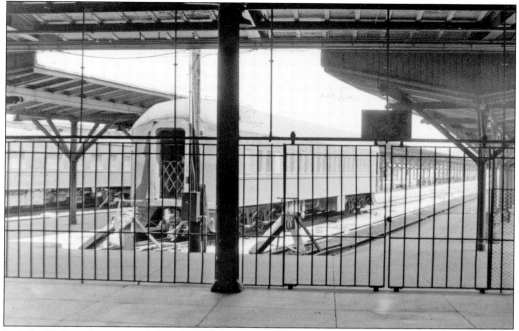

In July 1969, only one track has been left clear for arrival or departure of trains. Heavyweight coaches such as the one seen here are beginning to be scrapped as quickly as the Southern can ship them. (Courtesy of David Steinberg.)

An unidentified man stands in front tracks 3 and 4, occupied by equipment belonging to the Tennessee Valley Railroad Museum. The building on the left is the station master's office. This building was vacated as space came available in the main terminal after downsizing had begun. (Courtesy of David Steinberg.)

A similar photograph can be taken today from a similar view, but instead of standing on the rear of a train, one can stand on today's Chattanooga Choo Choo stage inside the formal gardens. The gates of the concourse can be seen behind the boxcar stored on the same track. (Courtesy of David Steinberg.)

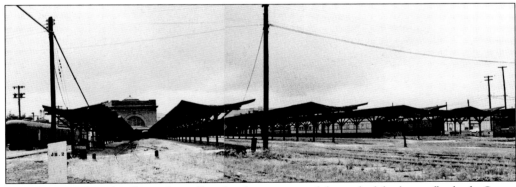

Two photographs spliced together offer a landscape view of the end of the butterfly sheds. Seven platform sheds serve the 14 tracks coming into the station. On the far left are the mail and express platforms, with baggage cars parked on the access track. This view is looking up track 3; a similar view can still be seen today from an access door to Building 2 at the Chattanooga Choo Choo. (Courtesy of David Steinberg.)

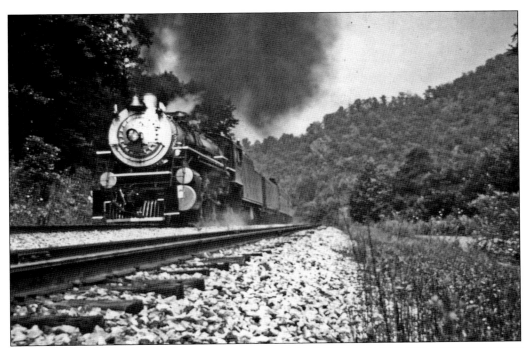

The Tennessee Valley Railroad Museum and the Southern Railway used Terminal Station in the 1960s and even a few times after it closed in the 1970s as a loading and unloading platform for excursion trains. Here Southern Railway No. 4501 pulls one of these consists. The "01," as the locomotive is affectionately called by railroad enthusiasts, is on display at the Tennessee Valley Railroad Museum's property. (Courtesy of the Chattanooga–Hamilton County Bicentennial Library.)

For the final part of Terminal Station's existence as a railroad depot, a false ceiling was built extending the entire span of the waiting room. This blocked the beautiful dome from view but was able to save the railroad heating costs. This photograph shows the walkway to nowhere on the second level above the waiting room. The false ceiling begins just to the right of the photographer. (Courtesy of David Steinberg.)

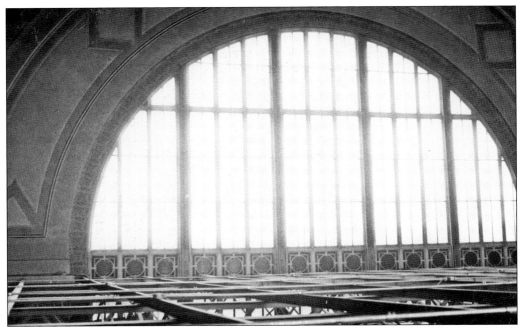

This picture is taken from the balcony looking over to the east windows of the waiting room. The support beams for the false ceiling can be seen. While controversial for blocking the view of the dome, it was necessary to counteract the tremendous cost of climate control within the station. (Courtesy of David Steinberg.)

The ornate moldings are still in place above each door entering in the station from the street or the train concourse. The detail work is incredible considering these pieces are cast concrete. A woodworker would have difficulty creating these, so the fact they are solid concrete is fascinating. (Courtesy of David Steinberg.)

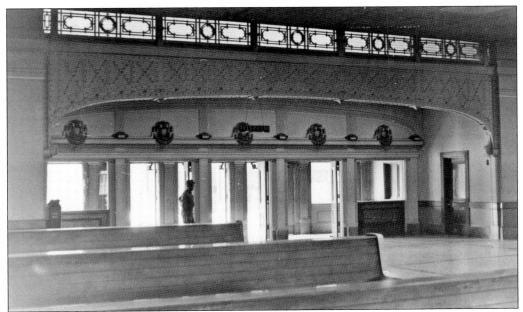

This view is looking out over the waiting room to the front entrance of the station. It must be a warm summer day, as all the windows and doors are kept open for a breeze. The false ceiling is now in place, as evident from the florescent bulbs. The railing from the balcony can be seen just underneath the ceiling. (Courtesy of David Steinberg.)

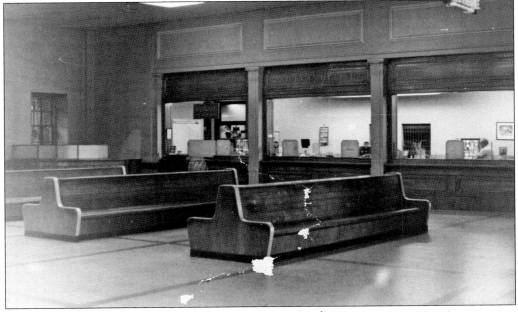

The ticket office, now no longer a hub of activity, awaits the next passenger wanting to secure a ticket on the *Birmingham Special*. Behind the ticket counter is a window with a set of bars, similar to an old-style banker teller's window. Prior to the end of Jim Crow laws, this was where the African American passengers would have purchased their tickets from a separate waiting room. (Courtesy of David Steinberg.)

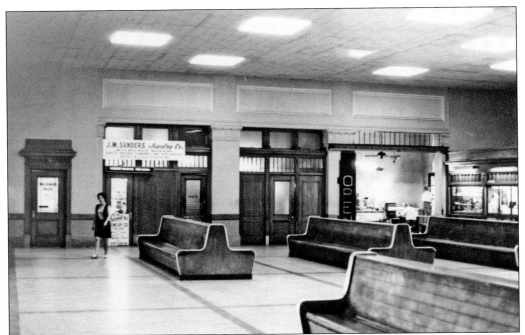

On the opposite side of the waiting room from the ticket office is the J. M. Sanders Jewelry Company, a tenant of the station during its last years in operation. Also shown are the lunch counter and newspaper stand in the far right corner. The newspaper stand is original to the station and was open until the station's last day of operation. (Courtesy of David Steinberg.)

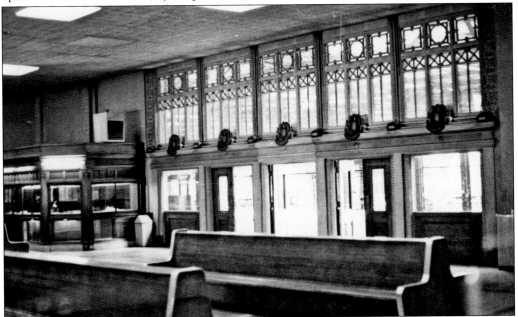

The gate shanty can be seen while looking through the three sets of open doors to the concourse. The newspaper stand is to the far left. The false ceiling is most evident in this photograph. (Courtesy of David Steinberg.)

TENNESSEE PUBLIC SERVICE COMMISSION

CORDELL HULL BUILDING
NASHVILLE, TENNESSEE 37219

CAYCE L. PENTECOST, CHAIRMAN
HAMMOND FOWLER, COMMISSIONER
Z. D. ATKINS, COMMISSIONER

JAMES L. TALBOT, EXECUTIVE SECRETARY
EUGENE W. WARD, GENERAL COUNSEL

OFFICIAL NOTICE OF HEARING

IN RE: APPLICATION OF THE CINCINNATI, NEW ORLEANS
 AND TEXAS PACIFIC RAILWAY COMPANY, A PART
 OF SOUTHERN RAILWAY SYSTEM, FOR AUTHORITY
 TO DISCONTINUE PASSENGER TRAINS NOS. 3 AND
 4 IN TENNESSEE

 DOCKET NO. R-5252

THE ABOVE MATTER IS SET FOR A PUBLIC HEARING ON TUESDAY, OCTOBER 14,
1969 AT 9:30 A.M. (EDT) IN ROOM 102 LOCATED ON THE LOBBY FLOOR OF
THE PROVIDENT BUILDING, EAST 6TH STREET AND LOOKOUT STREET (ACROSS
THE STREET FROM THE HAMILTON COUNTY COURTHOUSE), CHATTANOOGA,
TENNESSEE.

FOR THE TENNESSEE PUBLIC SERVICE COMMISSION:

JAMES L. TALBOT
EXECUTIVE SECRETARY

8-12-69

The Tennessee Public Service Commission was required to hold hearings before allowing the railroad to end any passenger service. This notice was sent to members of the public who wanted to attend to voice their concerns about losing train service. Most of these hearings ended the same way, with the discontinuation of the train. Here the final hearing takes place for the decision to terminate the *Royal Palm* between Cincinnati and Chattanooga. (Courtesy of David Steinberg.)

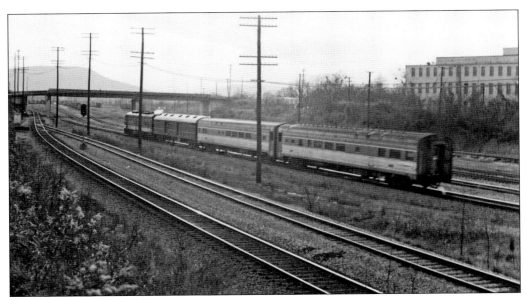

On November 23, 1969, the *Royal Palm* train No. 3 is seen at the Tinker Street viaduct in Chattanooga. The fate of the train has already been decided, and one week later, service would end between Chattanooga and Cincinnati. This would be the first time since 1880 that a passenger train had not run between the two cities. (Courtesy of David Steinberg.)

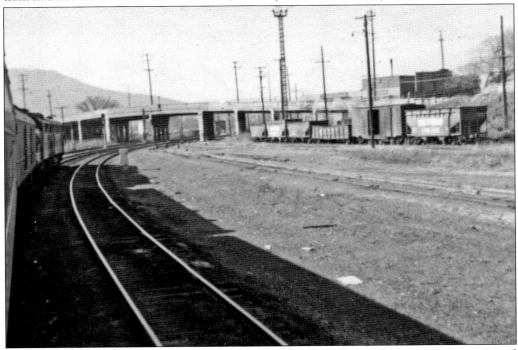

The last *Royal Palm* approaches the Central Avenue viaduct on November 30, 1969. David Steinberg is aboard taking photographs of this sad but historic moment. Steinberg was able to take the last southbound *Royal Palm* earlier in the day to Dalton, Georgia, where he changed to the last northbound for the trip back to Chattanooga. (Courtesy of David Steinberg.)

The *Royal Palm* winds its way for the last time onto the passenger main towards Main Street for the back-up movement into Terminal Station. Several photographers, presumably rail enthusiasts, are on hand to document the event. Main Street can be seen in the background in front of the large brick building. (Courtesy of David Steinberg.)

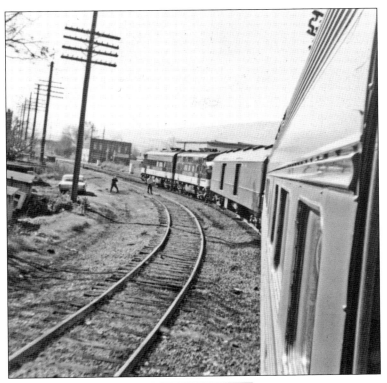

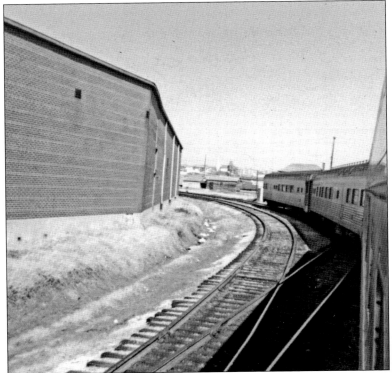

On November 30, 1969, the last *Royal Palm* is making a reverse move into Terminal Station. The rooftop of Terminal Tower can be seen just above the last car of the train. The conductor is on the rear platform of the train helping the engineer guide it to a stop by radio. (Courtesy of David Steinberg.)

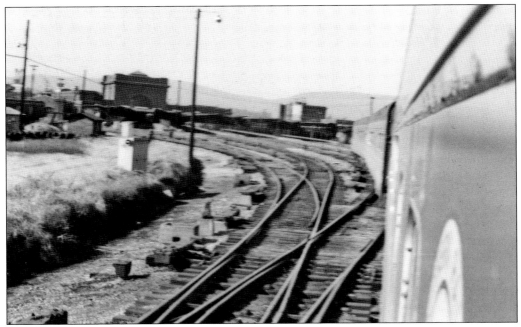

The *Royal Palm* continues its reverse move into what appears to be track 7. After it leaves Terminal Station, only one train will be left. Service to Atlanta and Cincinnati from Chattanooga will officially be cut. (Courtesy of David Steinberg.)

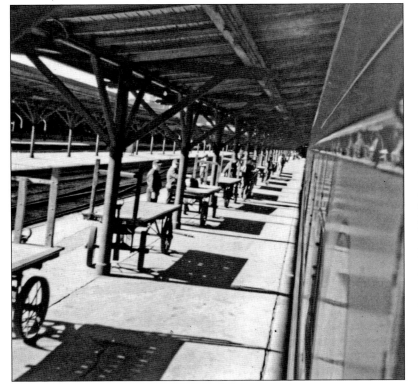

The final *Royal Palm* comes to a stop on Terminal Station's platform. The baggage carts seem to be lined up saluting the arrival of the train. Railroad employees and citizens alike came to see off the final train for Atlanta. (Courtesy of David Steinberg.)

The last crew operating the final
Royal Palm poses for David Steinberg's
photograph. The brakeman,
conductor, and fireman all agreed to
be photographed, but the engineer,
who was said to be very upset over
the discontinuance of his beloved
passenger train, demurred. The
employees who operated the *Royal
Palm* would either choose retirement
or would be reassigned to other
duties with the freight department.
(Courtesy of David Steinberg.)

E. L. Delooch is photographed in
his office at Terminal Station in July
1969. The passenger department in
Chattanooga has dwindled to less than
20 employees. As of November 1969, a
bare minimum staff was retained to keep
the station open for the *Birmingham
Special*. (Courtesy of David Steinberg.)

M. Sosfa, the passenger representative for Terminal Station, seems a bit busy with his paperwork when photographed in July 1969. The rack on the left holds schedules for rival railroads. This was important in order to plan connections with other carriers. (Courtesy of David Steinberg.)

"Mr. Emitt" is photographed by David Steinberg behind the original ticket counter at Terminal Station. The amount of paperwork and filing to be done by ticket agents was enormous, evident by the numerous filing cabinets behind the counter. (Courtesy of David Steinberg.)

CHATTANOOGA STATION COMPANY

Office of Superintendent

Chattanooga, Tennessee

August 7, 1970*

BULLETIN NO. 562

ALL CONCERNED:

Effective upon completion of tour of duty Tuesday, August 11, 1970, the positions of Tractor Operator, Mail and Baggage Handler, and Station Laborer at Chattanooga Station Company are abolished. The assigned occupants of these positions are:

E. Hickey	Tractor Operator
S. B. Ellerby	Tractor Operator
C. McDaniel	Tractor Operator
K. Higgins	Tractor Operator
	Mail & Baggage Handler
P. Reid	Mail & Baggage Handler
B. C. Thornton	Mail & Baggage Handler
C. A. Woodard	Mail & Baggage Handler
T. J. Conyers	Station Laborer
C. W. Davis	Station Laborer
P. Mathis	Station Laborer
C. N. Fears	Station Laborer

J. B. Hilton,
Superintendent

Bulletins are issued by the Chattanooga Station Company to make all employees aware of rule changes or unusual circumstances at Terminal Station. This bulletin is one of two that were inevitable but still dreaded. It serves as a final notice of the elimination of all jobs at the station. This was issued after the decision was made to discontinue the *Birmingham Special*, the last train serving Chattanooga on the Southern Railway. (Courtesy of David Steinberg.)

The last ticket agents for Terminal Station are shown on August 11, 1970, the final day of operation. Hoke Buice (left) and R. E. Pfitzer (right) will soon issue the last tickets out of Chattanooga for the *Birmingham Special*. (Courtesy of David Steinberg.)

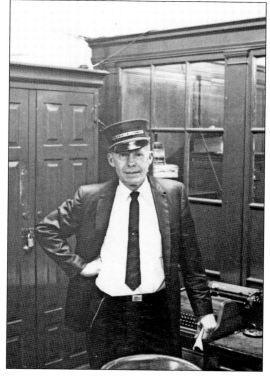

The stationmaster for Terminal Station is shown on the evening of August 11, 1970, inside his office just off the concourse. His desk is cleaned off, his office ready to close as he and his staff prepare for the last departure of the *Birmingham Special* later that night. (Courtesy of David Steinberg.)

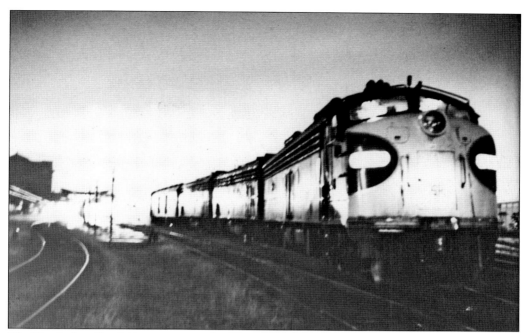

The *Birmingham Special* has now arrived at Terminal Station after backing into the platform tracks. The last train is unusually long because of the additional passengers wanting one last ride. The three diesel locomotives idle awaiting departure time. (Courtesy of David Steinberg.)

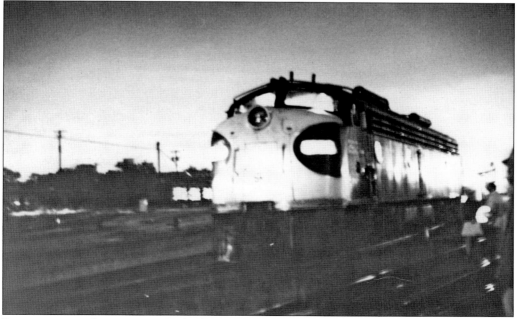

Rain appropriately accompanies the last train to serve Terminal Station. Though late at night, a small group of well-wishers greet the locomotive and to watch the final departure. (Courtesy of David Steinberg.)

On August 11, 1970, the *Birmingham Special* is about to depart Terminal Station at 11:35 p.m., never to return. This will close 61 years of service for the station. The rain causes the platform of tracks 7 and 8 to shine and the sides of the locomotives and cars to reflect. (Courtesy of David Steinberg.)

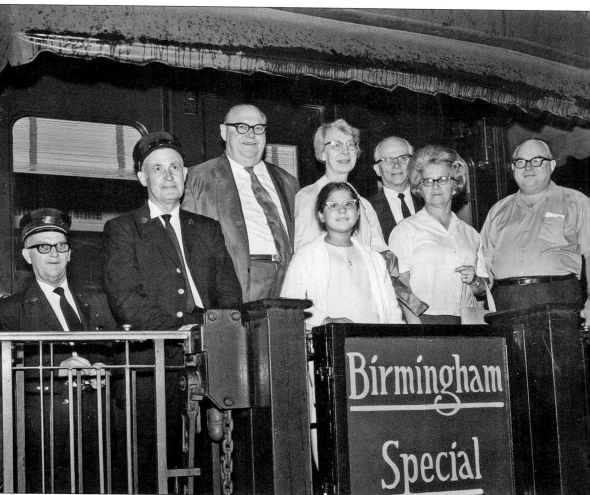

This could be considered the farewell portrait for the *Birmingham Special*. Pictured on the back platform of the train from left to right are the conductor and brakeman for the train, an unidentified man and young woman, and ticket agents R. E. Pfitzer and Hoke Buice with their wives. The car they are standing on is an executive office car for the Southern Railway. It was said the president of the railroad was inside sleeping at the time this photograph was taken. (Courtesy of David Steinberg.)

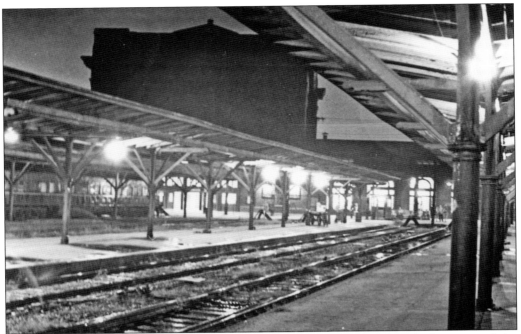

The *Birmingham Special* has just departed in this view on August 11, 1970, looking toward the station and concourse. The station head house looms ominously above the butterfly sheds. In a matter of minutes, the lights inside the station will be turned off for the last time. (Courtesy of David Steinberg.)

It's now August 12, 1970, minutes after the final train has departed Terminal Station. With the discontinuance of the *Birmingham Special*, Terminal Station's fate is uncertain. The concourse lies silent for the first time since the station opened in 1909. (Courtesy of David Steinberg.)

Seven

Rebirth as the Chattanooga Choo Choo

One year elapsed after the *Birmingham Special* became the last train into Terminal Station. Its fate unknown, the station sat boarded up and silent. The Southern Railway, like many railroads during this era, was not known for its preservation efforts for defunct stations. Some would become offices for work crews and yards, others were used for storage, but most were demolished for safety and financial reasons. The efforts to save Terminal Station from this fate began with a small article in the *Chattanooga Times Free Press* in late 1971. Allen Casey Jr., known in Chattanooga for owning three restaurants and a hotel, read the article, reporting how Southern Railway was taking bids from contractors for the demolition of Terminal Station. Casey was considering opening a new restaurant in town. A friend of his, Frank Worthington, was a former vice president for the Southern, and Casey knew he would be a good source of information. Casey saw Terminal Station as a potential location for his new restaurant. Worthington, encouraged by the idea, arranged a tour of the station. Convinced that converting the station was not only feasible but economically viable, Worthington arranged a meeting between Allen Casey and the president of the Southern, Graham Claytor Jr. During this brief meeting, Casey made his case for the preservation of the depot as a restaurant and hotel, all with the theme of a song that made Chattanooga synonymous with railroads, "Chattanooga Choo Choo." After the presentation, Claytor immediately called in all the vice presidents located in the surrounding offices for an impromptu meeting. He explained Casey's idea and decreed that any and all efforts would be made by the railroad to support Casey. He then pointed out a stack of 80 letters sent to him from the citizens of Birmingham, Alabama. Recently, the Southern had razed the historic turn-of-the-century Birmingham Terminal Station, resulting in a tremendous public outcry. "Right here are 80 letters that I have received from railroad historical buffs from Birmingham blaming me for tearing down their station. I do not want to be blamed for something like this again," Claytor told the group. Immediately following this meeting, Casey began to raise capital for the massive renovation that would be needed to transform Terminal Station into what would become the Chattanooga Choo Choo Vacation and Hotel Complex. The theme of the complex, based on Glenn Miller's song from 1941, acted as a great centerpiece around which the new hotel, restaurants, and shops would bloom. The estimated financial backing needed to rebuild the complex would be in the range of $5 million. Scotty Probasco, a banker with the American National Bank, offered Casey a $2.5-million loan with the stipulation that Casey match his loan. Within 27 days, Casey drew together 24 investors who compiled $100,000 dollars each. These investors were the original directors of the Chattanooga Choo Choo. With all the capital in place, Casey proceeded to incorporate his new company. He and the investors decided on a name for the corporation that would keep the public unaware of what was to happen to Terminal Station. They dubbed themselves "The Quiet Company" and applied for this name with the Secretary of State of Tennessee and the Chamber of Commerce.

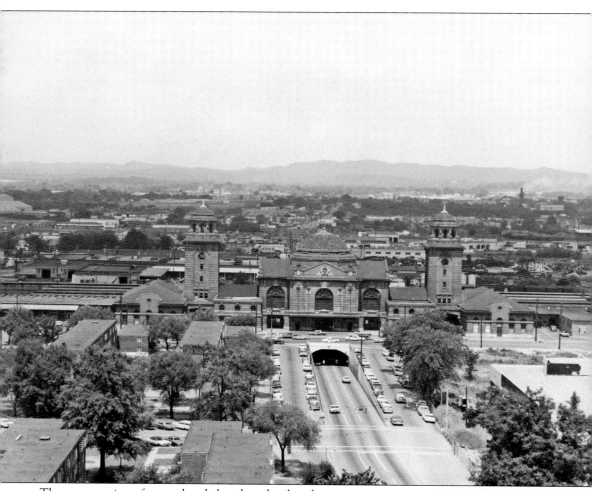

The preservation of unused and abandoned railroad stations was a new concept in the late 1960s and early 1970s, as passenger traffic took a steady decline. It took a tragedy in another city to preserve Terminal Station in Chattanooga. Birmingham Terminal Station, shown here, was demolished by the Southern Railway despite the efforts of preservationists. These preservationists wrote to the president of the Southern Railway blaming him for the station's destruction. This prompted the railroad to look more closely at saving unused passenger stations for public use. (Courtesy of the Chattanooga–Hamilton County Bicentennial Library.)

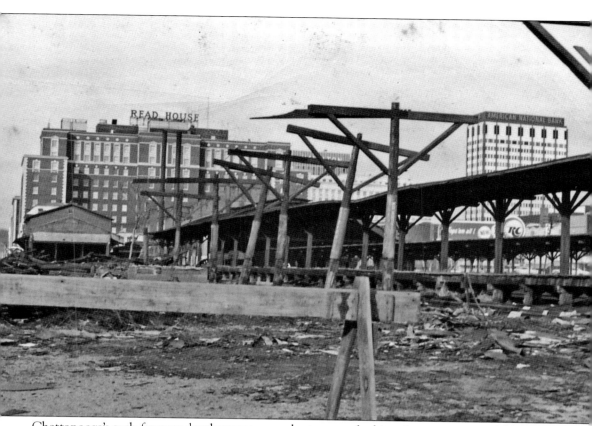

Chattanooga's rush for new development caused a travesty for historic preservation. After the departure of the Louisville and Nashville Railroad's last passenger train on May 1, 1971, Union Depot's fate hung in the balance. Despite being on the National Register of Historic Places, Union Depot was leveled in 1973 for office building space and the new library. The failure to save Union Depot inspired many Chattanoogans to make sure Terminal Station did not suffer the same fate. (Courtesy of the Chattanooga–Hamilton County Bicentennial Library.)

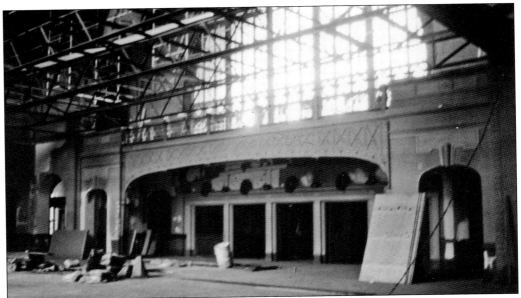

After Terminal Station's purchase by The Quiet Company, the proprietors of the future Chattanooga Choo Choo Hotel and Vacation Complex, work renovating the station began immediately. Here the false ceiling is removed piece by piece to reveal the dome which had not been visible in almost a decade. New paint would adorn the ceiling and walls, and the doors would be completely refurbished. (Courtesy of the Chattanooga Choo Choo.)

The concourse floor is being removed to install copper piping and drains for the new restaurant, called the Palm Terrace. Where the photographer is standing will be the kitchen area of the restaurant, while out in the wider portion of the concourse will be the dining room. (Courtesy of the Chattanooga Choo Choo.)

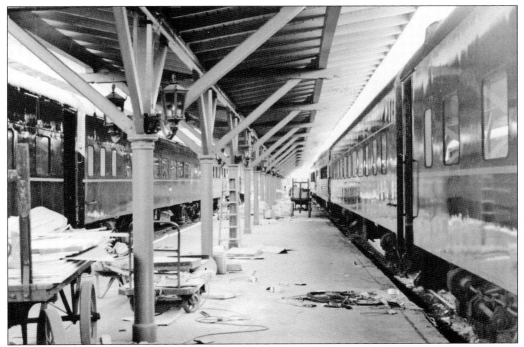

The former passenger coaches are being renovated into hotel room spaces. Each car contains two hotel rooms, and the former men's and women's restrooms have been converted to house bathtubs and other modern amenities. Each car was purchased at the scrap value price of $2,500 and renovated at a cost of $10,000 each. (Courtesy of David Steinberg.)

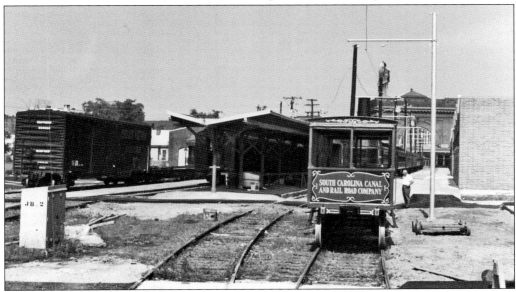

The finishing touches are taking place on the hotel building (Building 1 at the Chattanooga Choo Choo today) and the now appropriately named Victorian Sleeping Cars. A former visitor to Terminal Station, the *Best Friend of Charleston*, is on hand to participate in opening events at the Chattanooga Choo Choo. (Courtesy of David Steinberg.)

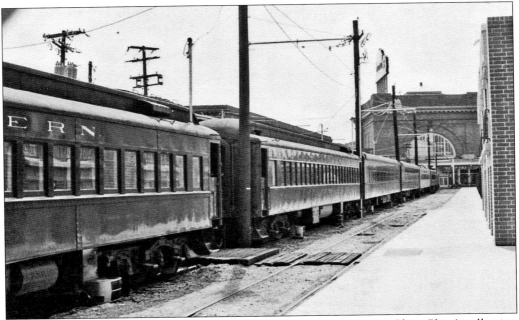

The empty track with overhead wires will be utilized by the Chattanooga Choo Choo's collection of trolleys to carry people from the rear parking lots to the restaurants and hotel building. The first two Victorian Railcars on the left are former Southern Railway heavyweight coaches, one of which is believed to have been built in 1916. (Courtesy of David Steinberg.)

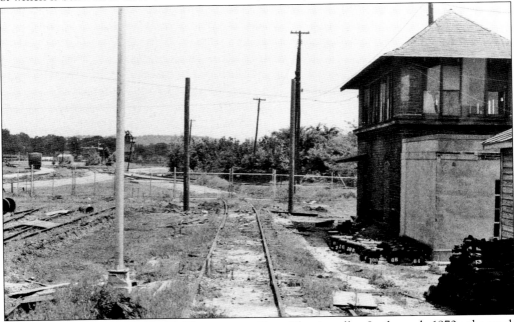

This is the end of the line for the Chattanooga Choo Choo's trolley. In the early 1970s, the track still connected to the outside freight railroad and even allowed the Tennessee Valley Railroad to bring trains into the facility. Terminal Tower, on the right, sits unused at this time. Notice the collection of dwarf signals at the bottom of the tower. (Courtesy of David Steinberg.)

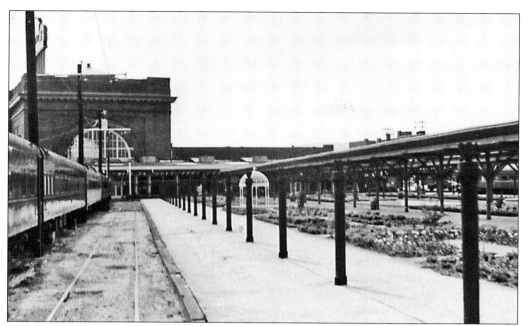

The formal gardens are seen on the right from this view on board the streetcar. Tracks 5 through 10 were taken out and replaced by the gardens. A few of the butterfly sheds were removed to allow additional sunlight to reach the garden and to build the hotel building toward the rear of the platforms. (Courtesy of David Steinberg.)

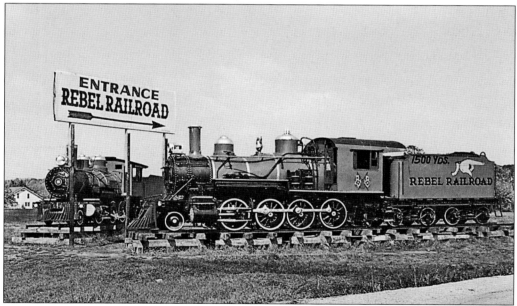

It is only appropriate that a facility named the "Chattanooga Choo Choo" has a locomotive to represent the train in the famous song. The locomotive was purchased from the Rebel Railroad (later to become Silver Dollar City, then Dollywood) for $5,000 and brought down to Chattanooga for display. This postcard shows the soon-to-be *Chattanooga Choo Choo* on the left at the entrance of the park. (Courtesy of the Chattanooga–Hamilton County Bicentennial Library.)

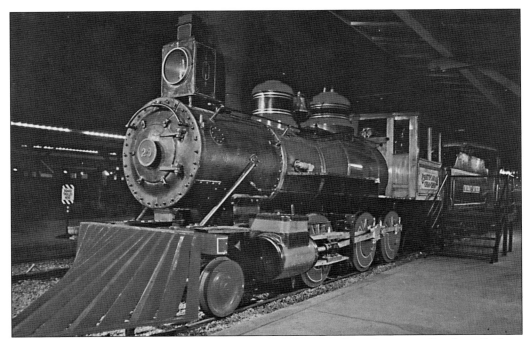

The Chattanooga Choo Choo's steam locomotive, while painted as a Cincinnati Southern Railway locomotive, actually began its service life on the Blue Ridge Railway outside of Knoxville, Tennessee. Built in 1914, it was used for logging operations. Similar engines would have plied the rails on the Cincinnati Southern in the late 1800s. (Courtesy of the Chattanooga Choo Choo.)

The New Orleans streetcar operating at the Chattanooga Choo Choo originally ran on the Canal Street line from 1924 until its retirement in 1960. In this photograph, the streetcar on the left is the one currently used at the Choo Choo. Originally numbered 952, this trolley was manufactured by the Perley Thomas Car Works of High Point, North Carolina. (Courtesy of the Chattanooga–Hamilton County Bicentennial Library.)

Eight

THE CHATTANOOGA CHOO CHOO BECOMES REALITY

The Chattanooga Choo Choo has become one of the most unique properties in the South. It introduced the idea of refurbishing historic property like former railroad depots for public use. The original plan called for two large restaurants, over a dozen retail outlets, four lounges, and just under 150 guest rooms, including 48 rooms inside remodeled passenger railroad cars. These "Victorian Railcars," as they came to be known, were lined up along the former passenger loading platforms to give the impression one is boarding a long-distance train after checking in to the hotel. Three sets of platform tracks were not going to be used by the railcars. These were transformed into the formal gardens. Since opening in 1973, these gardens have become famous for their tulip collection and award-wining rose garden. The main terminal building, with the grand dome restored to its original glory, became a sun-bathed banquet area. The passenger concourse was remodeled as a restaurant called the Palms Terrace, the original space now completely enclosed with large glass windows overlooking the formal gardens and the Victorian Railcars. The latticework covering the support trusses of the roof is reminiscent of the Tivioli Gardens in Copenhagen. The hotel portion of the Choo Choo began with what is now known as "Building 1." This structure is located toward the rear portion of the platforms. When the facility opened in April 1973, it was immediately obvious that expansion was needed. In 1979, Building 2 debuted as a 100-room expansion, along with an outdoor pool, hot tub, a bar called Pennsylvania Station, and a new and expanded laundry room. Over the following two years, the largest and most costly expansion took place with the addition of Building 3, adding another 125 guest rooms, another outdoor pool with a waterfall, and a bar underneath the waterfall. This was the first and only non-railroad-themed building. In the late 1970s, expansion also began on the easternmost portion of the grounds. The original tower that controlled the interlocking within the station was in this area. This was remodeled as a pro shop for the new tennis courts built nearby. An ice skating rink was also constructed in the southeastern corner, and the parking lot was expanded toward the rear of the property. "Iceland," as it was called, only existed for a few years until financial hardship closed it. The former ice rink is now used as indoor convention space for concerts, trade shows, and other functions. In 1989, the Chattanooga Choo Choo was purchased by a group of local businessman organized as Choo Choo Partners, LLC.

David Steinberg, the teenage rail fan who took so many photographs of Terminal Station in operation, had become an ordained rabbi and full-time trolley conductor at the Chattanooga Choo Choo. Here he greets a family ready to board the streetcar at the new convention center station on the property. Though used as a publicity photograph for the Choo Choo, one might notice how excited the little girl is to get on the trolley. (Courtesy of the Chattanooga Choo Choo.)

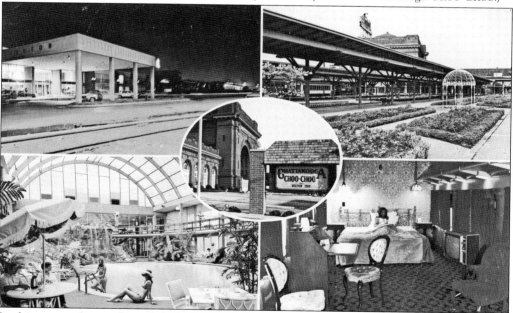

In this postcard view, four of the biggest attractions at the Choo Choo can be seen. Clockwise from the top left are the Choo Choo Hilton and check-in desk, formal gardens, the interior of a Victorian Railcar, and indoor pool and Trolley Car Café. Not only were the train cars unique, but they were also some of the most luxurious accommodations in Chattanooga. (Courtesy of the Chattanooga Choo Choo.)

The renovated waiting room and dome are now referred to as the Grand Dome. This function space could be used as restaurant space or for special events. The Palms Terrace restaurant was incredibly popular for Chattanoogans and tourists who wanted to eat beneath what was one of the largest domes of its time. (Courtesy of the Chattanooga Choo Choo.)

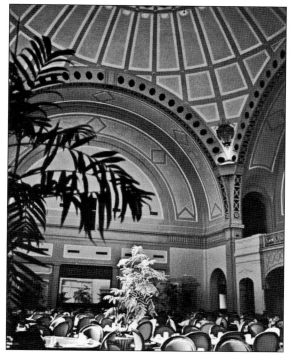

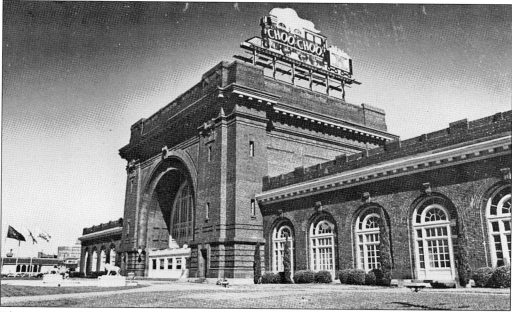

The exterior of the station has been completely remodeled, new landscaping has been installed, all wooden surfaces are freshly painted, and a large fountain sits in the former roadway to the entrance. The area between the outer and inner doors going into the lobby has been turned into a function space called the Fountain Room. The greatest change is the placement of the neon Choo Choo sign on top of the head house. The red glow of the Chattanooga Choo Choo can be seen for miles at night and has become a Chattanooga landmark. (Courtesy of David Steinberg.)

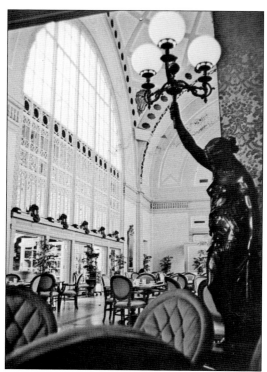

This postcard view was taken from the Victorian Lounge (the former lunch counter for Terminal Station) looking into the Grand Dome. The doorways lead into the Palms Terrace restaurant. The statue in the foreground can still be seen in the Victorian Lounge today. (Courtesy of the Chattanooga Choo Choo.)

Another postcard view features the two lighted gazebo fountains inside the formal gardens. The gardens, initially famous for the collection of tulips, are now award-winning rose gardens. Some visitors say the gardens alone are worth the trip to visit the Chattanooga Choo Choo. (Courtesy of the Chattanooga Choo Choo.)

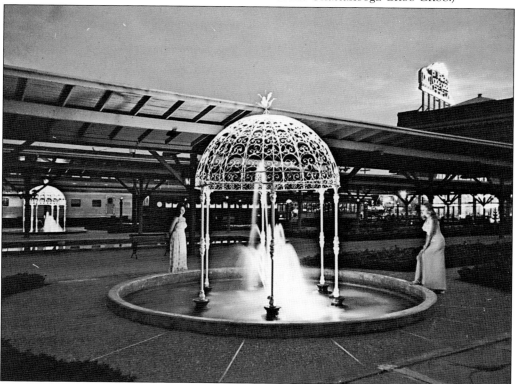

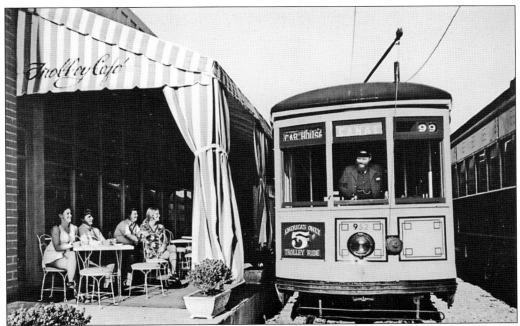

David Steinberg is at the controls of his beloved trolley, the former New Orleans Public Transit No. 952. The streetcar is passing the Trolley Café, a bistro-style restaurant within the first hotel building. The café overlooks the streetcar tracks on one side and the indoor pool with a waterslide on the other. (Courtesy of the Chattanooga Choo Choo.)

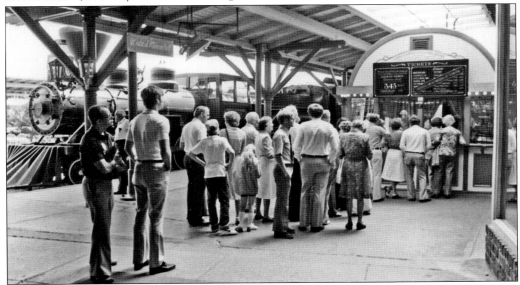

A crowd gathers during the lunch rush to order "tickets." Ordering a meal at the Palms Terrace was an exciting experience. Entrée items were matched with destinations on what resembled a train schedule board. One ordered a meal by purchasing a ticket to a particular destination. For example, if one purchased a ticket for New York City, one got the New York strip steak. Once seated inside the restaurant, tickets would be taken up and corresponding meals brought out. (Courtesy of the Chattanooga Choo Choo.)

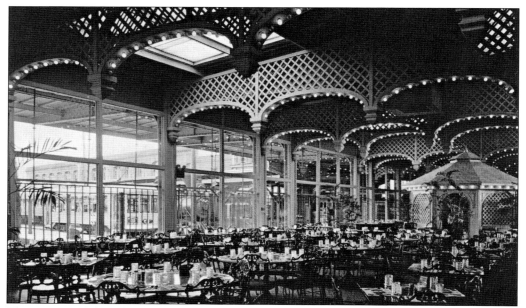

The interior of the Palms Terrace was designed to resemble the Tivoli Gardens of Copenhagen. Little has changed since the early 1970s, when this photograph was taken, but that the name of the restaurant has changed to "The Gardens." (Courtesy of the Chattanooga Choo Choo.)

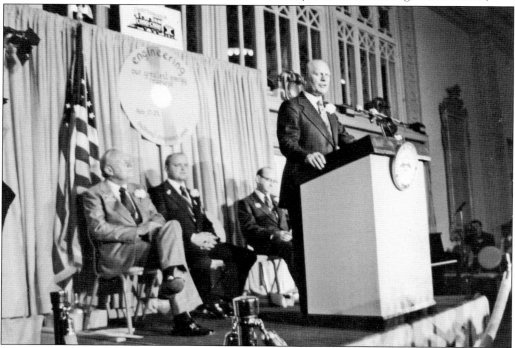

Terminal Station has a history of presidential visits, including Franklin Delano Roosevelt, Woodrow Wilson, and Teddy Roosevelt. In this photograph, then–Vice President Gerald Ford is the keynote speaker for a gathering of industrial engineers inside the Grand Dome. (Courtesy of the Chattanooga Choo Choo.)

Vice President Ford (fourth from left) sits with other invited guest at a banquet inside the Palms Terrace. The insert in the wall behind Vice President Ford was once a window separating the ticket office from the train concourse. (Courtesy of the Chattanooga Choo Choo.)

After the banquet, Vice President Ford is pictured with his wife, Betty, inside the Wabash Cannonball Club Car. Alan Casey, the proprietor of the Chattanooga Choo Choo, actually purchased a club car once used on the Wabash Railroad, so the name of the bar would be entirely appropriate. (Courtesy of the Chattanooga Choo Choo.)

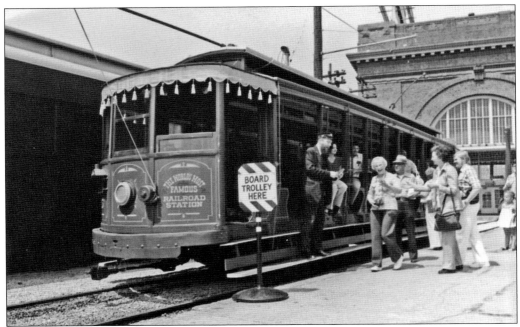

In the 1970s, two streetcars were used at the Choo Choo. The streetcar pictured is an open-air trolley from South America. David Steinberg welcomes his guest aboard before he begins his tour around the facility. This streetcar was sold back to a company in South America after safety and mechanical issues permanently sidelined it. (Courtesy of the Chattanooga Choo Choo.)

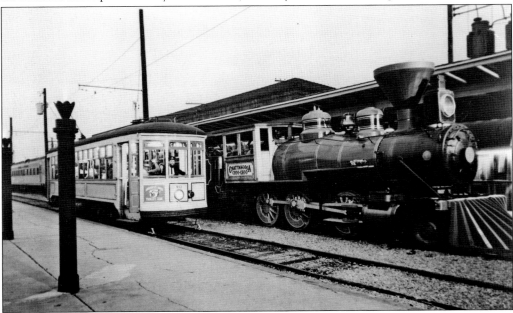

Pictured are what could be the two most photographed entities in Chattanooga. Visitors from all around the world gather to have their picture taken in front of the world famous *Chattanooga Choo Choo*. David Steinberg pulls his streetcar up to his stopping point after his tour around the property. (Courtesy of the Chattanooga Choo Choo.)

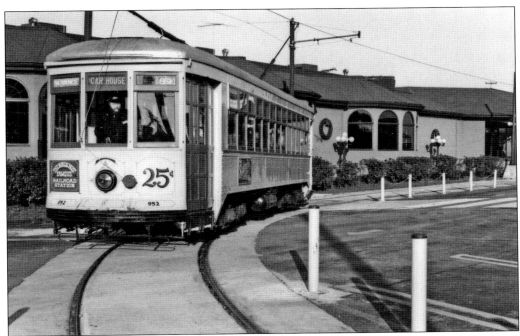

The times are changing at the Choo Choo. The trolley tracks have been extended past the conference center and now duck underneath a portion of the original concourse before reversing for another tour. The most important change is the price of the tours—the former famous 5¢ tour has now been raised to a quarter. (Courtesy of David Steinberg.)

An unidentified family takes a portrait in front of the New Orleans streetcar. This trolley still operates today on a daily basis, offering hourly historical tours describing the Terminal Station of yesterday and the Chattanooga Choo Choo of today. Of course the traditional call of "all aboard" is announced before any departure. (Courtesy of the Chattanooga Choo Choo.)

The photographer must be talented to hold a steady shot inside a rolling streetcar. Here the New Orleans trolley is finishing its out-and-about run. Notice the future motorman discussing operating the trolley with the driver. The wooden seats are original from 1924 and were built in Philadelphia and shipped to High Point, North Carolina, for assembly inside. (Courtesy of the Chattanooga Choo Choo.)

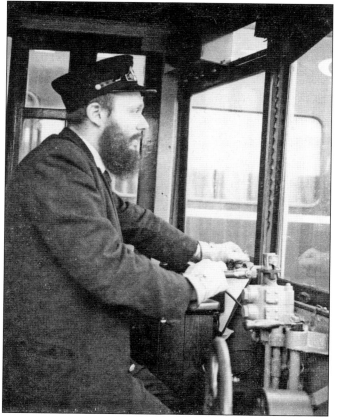

The Chattanooga Choo Choo has a history of talented and charismatic trolley drivers, as labeled by the employees. By far the most enthusiastic was the first trolley driver, who was none other than David Steinberg. Steinberg is shown at the controls of the 952 in a portrait taken for publication by the Chattanooga Choo Choo. (Courtesy of the Chattanooga Choo Choo.)

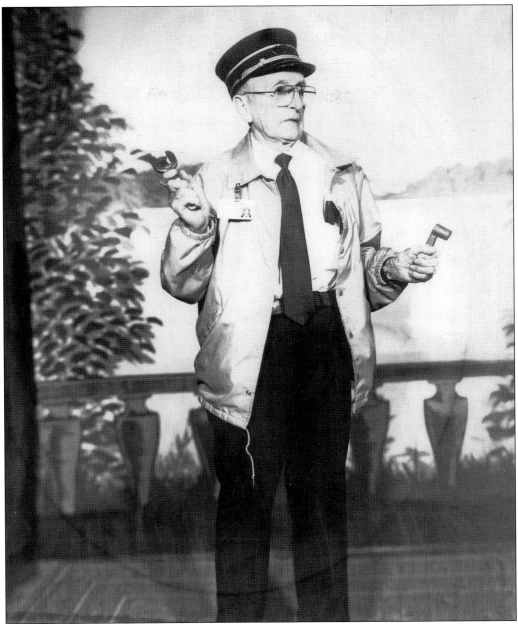

After David Steinberg left the Chattanooga Choo Choo, Howard Summers took his place as the Choo Choo's trolley driver and historian. Summers won over guests with his charming demeanor and obvious passion for his job. (Courtesy of Millie Summers.)

The formal gardens require constant upkeep and maintenance. Pictured are landscaping employees Paul Landry and Henry Dicks. In the summer of 1976, the gardens featured over 4,000 red and white begonias and 6,000 marigolds. (Courtesy of the Chattanooga Choo Choo.)

Allen Casey Jr. (at left), chairman of the board for the Chattanooga Choo Choo, chats on board the streetcar with Mose Siskin. Siskin's father founded Siskin Steel, a major employer in the Tennessee Valley area. Siskin also donated millions of dollars to local charities and the University of Tennessee at Chattanooga. His philanthropic deeds inspired the Chattanooga Choo Choo to officially dedicate the trolley in his name. (Courtesy of the Chattanooga Choo Choo.)

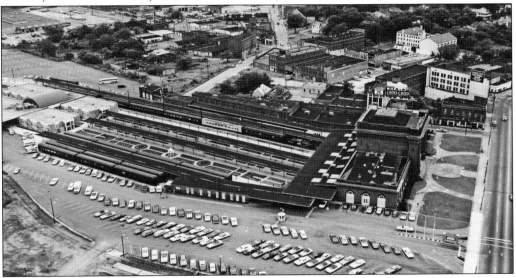

This aerial view from the early 1970s gives a great overview on how the Chattanooga Choo Choo is arranged. The farthest butterfly shed is the only one still its original length; the rest have been removed entirely or shortened to accommodate the hotel building. Underneath the glass dome of the hotel is the indoor pool. The skylights on the concourse help lighten the interior of the Palms Terrace restaurant. The one silver train car on the opposite side of the gardens is Dinner in the Diner, where the Choo Choo has replicated first-class service on board an authentic former New York Central dining car. Even more expansion would take place in 1978, with the addition of a second hotel building, located just south of the original building (where a large touring bus is parked in the lot). The third hotel building would be built in 1981 where a wooded lot existed also near the south parking lot. (Courtesy of the Chattanooga Choo Choo.)

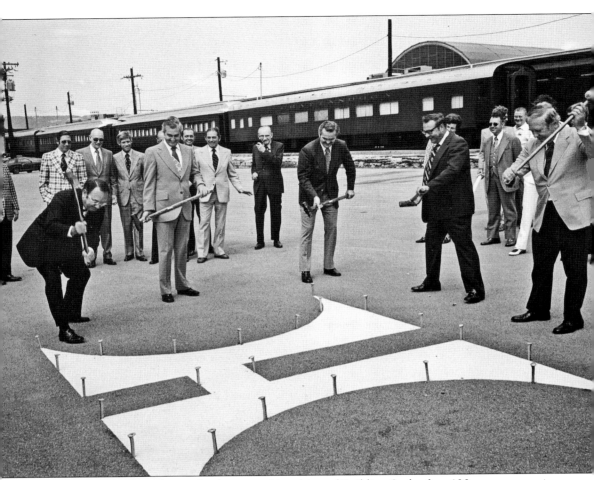

The golden spike is driven for the ground breaking of Building 2, the first 100-room expansion of the Chattanooga Choo Choo. Alan Casey Jr. is about to drive the first spike in. All the gentlemen present in the photograph represent the Hilton chain of hotels, former Southern Railway management, or Chattanooga Choo Choo investors. (Courtesy of the Chattanooga Choo Choo.)

Nine

THE FUTURE
OF TERMINAL STATION
AND THE CHATTANOOGA
CHOO CHOO

The future of Terminal Station and the Chattanooga Choo Choo looks bright. Chattanooga has been rated one of the top family destinations in the United States and one of the best places to live. The area surrounding the Choo Choo is undergoing a major restoration. The Market and Main Historic District (the area surrounding the corners of Market Street and Main Street) has seen many abandoned buildings become new restaurants, condos, coffee shops, and offices. The Electric Shuttle, which transports its patrons free of charge from the aquarium near the Tennessee River through the heart of downtown to the Choo Choo, brings a constant flow of tourists and Chattanoogans alike to the Choo Choo's complex. These developments have brought new life to an area once all but abandoned. In 2009, the Chattanooga Choo Choo celebrates Terminal Station's 100th anniversary by hosting several major events, including a concert featuring the Glenn Miller Orchestra, culminating with a giant birthday party planned for December 1, 2009, the actual opening date of the station 100 years prior. Plans are underway to bring passenger service back to Terminal Station. The Chattanooga Choo Choo, Norfolk Southern, the City of Chattanooga, and the Tennessee Valley Railroad Museum are hoping to restore excursion train service to the Choo Choo in the near future. Terminal Station would serve as a major depot for the railroad museum, taking passengers to their main facility in East Chattanooga or on an excursion to and from the north Georgia area. If this comes to fruition, Terminal Station will once again host passengers, hopefully for another 100 years and many generations to come.

Very little has changed in the 100 years since the terminal has been completed. The infamous walkway to nowhere still exists, though not accessible to the general public. (Courtesy of the author.)

The front desk for the hotel portion of the Chattanooga Choo Choo is built within the original waiting room and extends some 20 feet from the original wall. The mirror is where the original ticket office was located. (Courtesy of the author.)

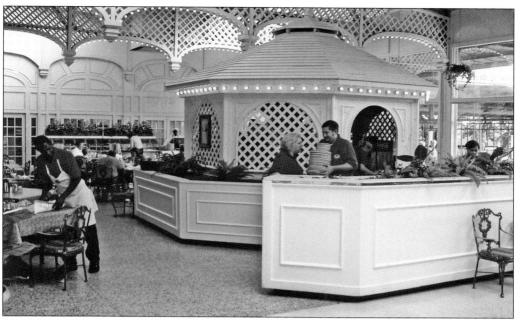

The former Palms Terrace is now renamed the Gardens Restaurant. The restaurant is approximately one-third its original size, as a portion is now a meeting hall called the Roosevelt Room. The restaurant has kept the ambiance of an outdoor garden and patio. (Courtesy of the author.)

The original concourse inside the gates has been completely enclosed and is now climate controlled. The portion of the concourse closest to the original platforms is now the main gateway in and out of the Chattanooga Choo Choo. One can also follow the platforms and butterfly sheds to the guest rooms or follow the path to the former Baggage/Express Building for retail shops and additional restaurants. (Courtesy of the author.)

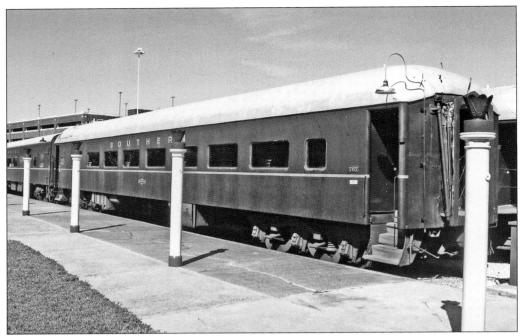

A rebuilt Southern Railway heavyweight coach now serves as two guest rooms at the Chattanooga Choo Choo. The support columns that used to hold the wooden butterfly shed are now gas lanterns that are lit on weekends and special occasions. (Courtesy of the author.)

Pennsylvania Station, once a bar serving guests staying in Building 2, is now used by private parties. A more modern hot tub is located in Building 3, and the former hot tub here has been converted to a fountain. (Courtesy of the author.)

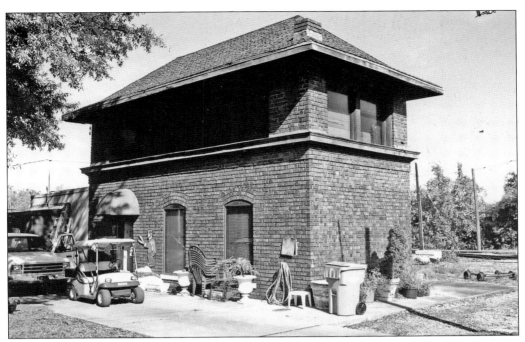

Terminal Tower has seen almost constant use, even after the facility was converted from a train station. It has been a tennis pro shop and human resources office for the Chattanooga Choo Choo. Today Terminal Tower is used by the landscaping department. Downstairs is a storage, locker, and restroom facility, while upstairs is the office for the landscaping director. (Courtesy of the author.)

The former eight-track coach yard, now the parking lot, used this crane to replace wheel sets underneath passenger equipment. Wheels were removed from the train cars by use of a drop pit—an opening beneath the rails of the tracks which allows heavy items to be lowered from beneath the train car. The crane would raise the old wheel set out and replace it with a new one. This enabled wheels to be changed without having to lift the heavy car. (Courtesy of the author.)

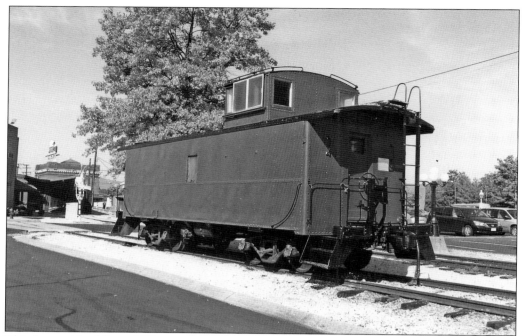

This former Norfolk and Western Railway caboose was built in 1941 and is currently on display in the parking lot of the Chattanooga Choo Choo. Recently, the Choo Choo has refurbished the exterior with new paint. Plans for the caboose are still uncertain, but for now, it's being well preserved by the maintenance staff. (Courtesy of the author.)

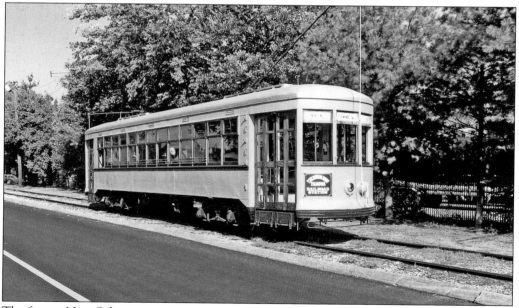

The former New Orleans streetcar is seen giving one of its hourly tours. The track the streetcar uses is the former Central of Georgia rail line to access its freight station adjacent to Terminal Station. When reaching the rear of the property, the streetcar makes a 180-degree turn and comes up the original track 9. (Courtesy of the author.)

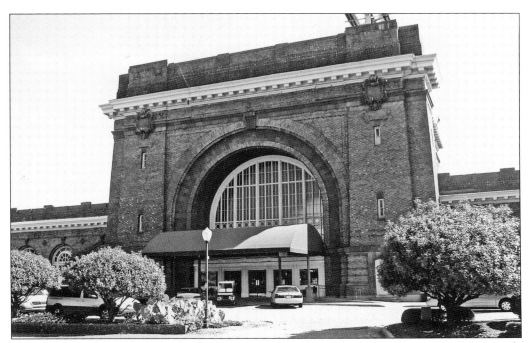

The Chattanooga Choo Choo's lobby and front desk are located in the former waiting room inside Terminal Station. When Holiday Inn became the operator in 1989, the restaurant was removed from the Grand Dome and the lobby moved in. (Courtesy of the author.)

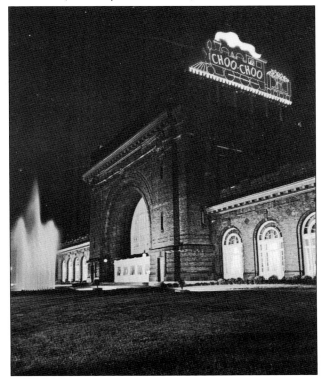

Night falls on the Chattanooga Choo Choo, and the neon sign is lit on top of the roof. The fountains in front are a welcoming sight to visitors of the facility. Thanks to the Chattanooga Choo Choo, Terminal Station will see another 100 years of service to the public. (Courtesy of the Chattanooga Choo Choo.)

DISCOVER THOUSANDS OF LOCAL HISTORY BOOKS
FEATURING MILLIONS OF VINTAGE IMAGES

Arcadia Publishing, the leading local history publisher in the United States, is committed to making history accessible and meaningful through publishing books that celebrate and preserve the heritage of America's people and places.

Find more books like this at
www.arcadiapublishing.com

Search for your hometown history, your old stomping grounds, and even your favorite sports team.

Consistent with our mission to preserve history on a local level, this book was printed in South Carolina on American-made paper and manufactured entirely in the United States. Products carrying the accredited Forest Stewardship Council (FSC) label are printed on 100 percent FSC-certified paper.

MADE IN THE USA